MOON VALLEY

COLORING BOOK

ILLUSTRATED BY MARIA TROLLE

GIBBS SMITH
TO ENRICH AND INSPIRE HUMANKIND

To my Family

26 25 24 23 22 5 4 3 2

Moon Valley
Illustrations © 2021 Maria Trolle
www.mariatrolle.se
Instagram: @maria_trolle

Original title: *Måndalen*
Swedish edition copyright © 2021 Bookmark Förlag, Sweden.
All rights reserved.

English edition copyright © 2022 Gibbs Smith Publisher, USA.

Gibbs Smith
P.O. Box 667
Layton, Utah 84041

1.800.835.4993 orders
www.gibbs-smith.com

ISBN: 978-1-4236-6168-9

THIS BOOK BELONGS TO:

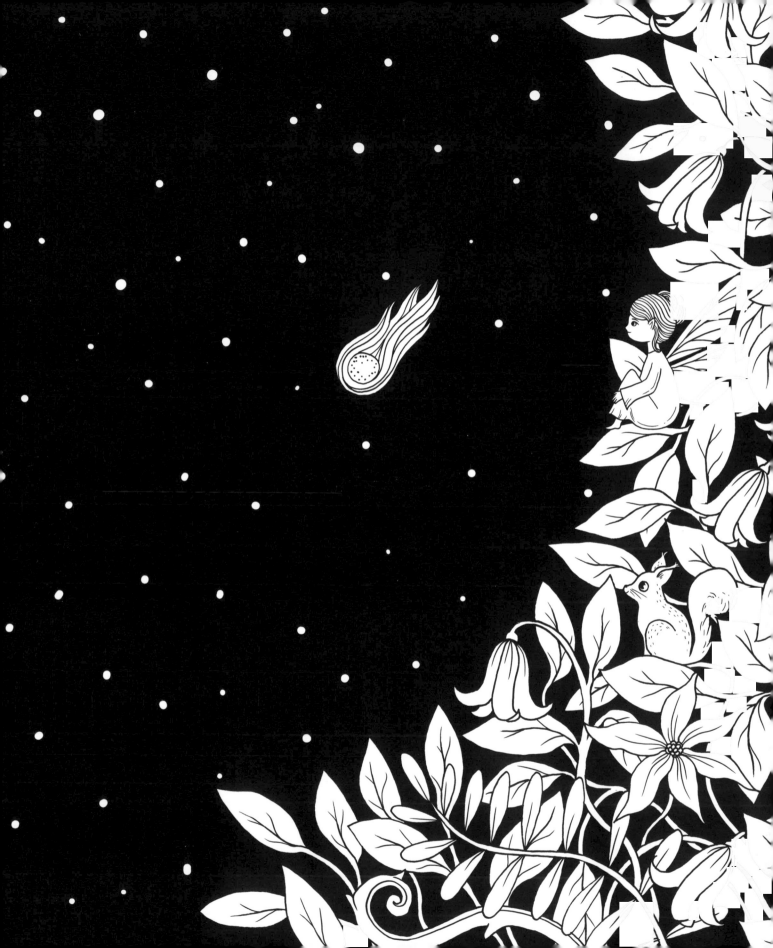

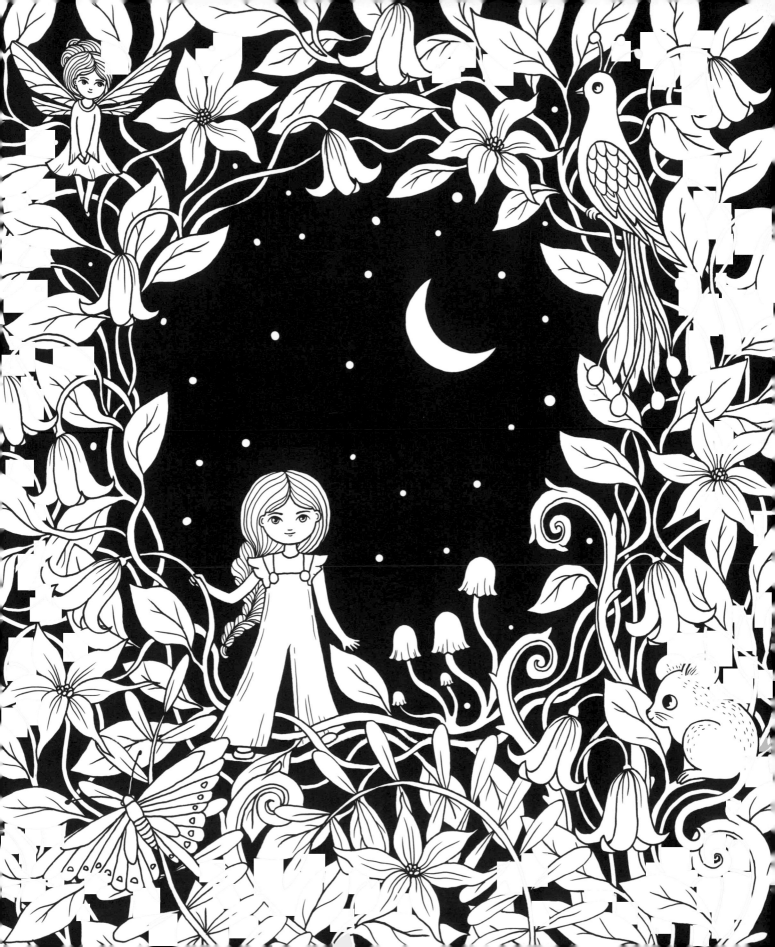

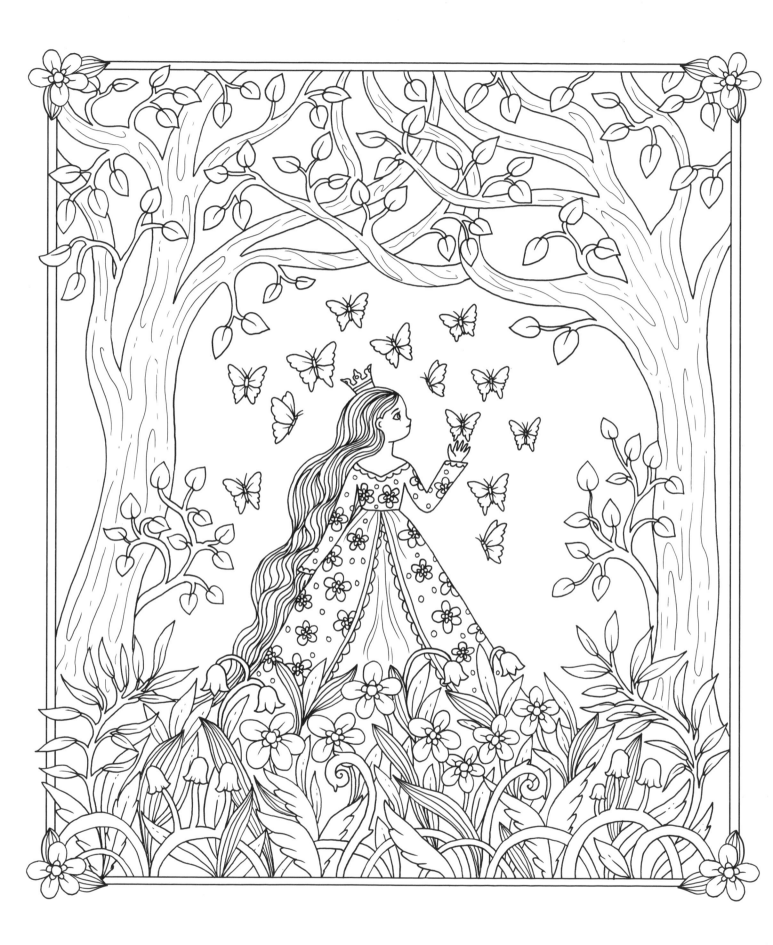

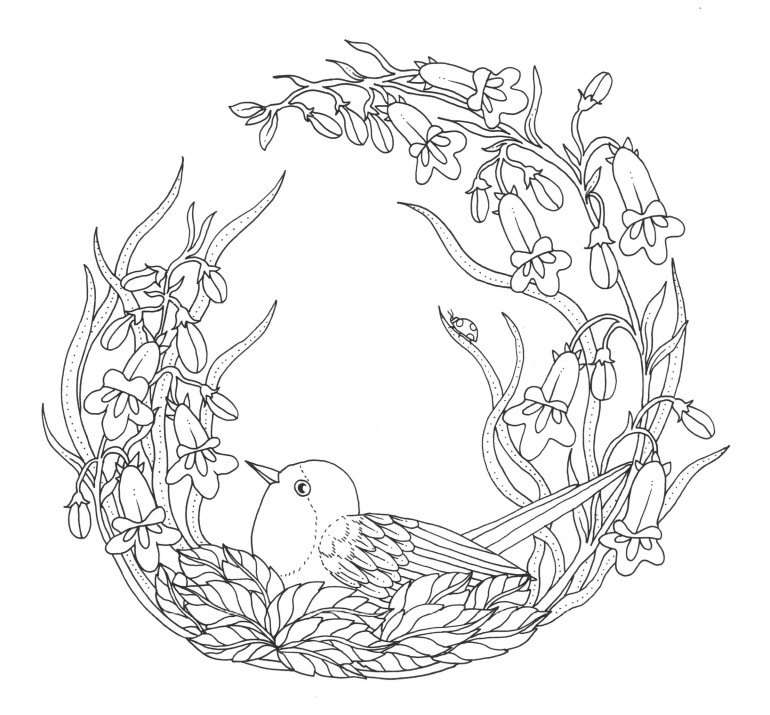

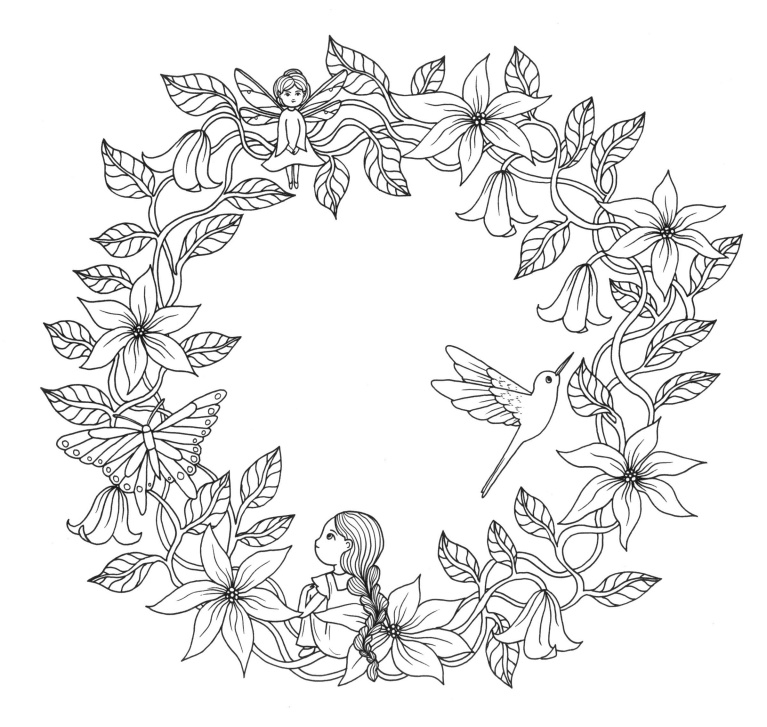

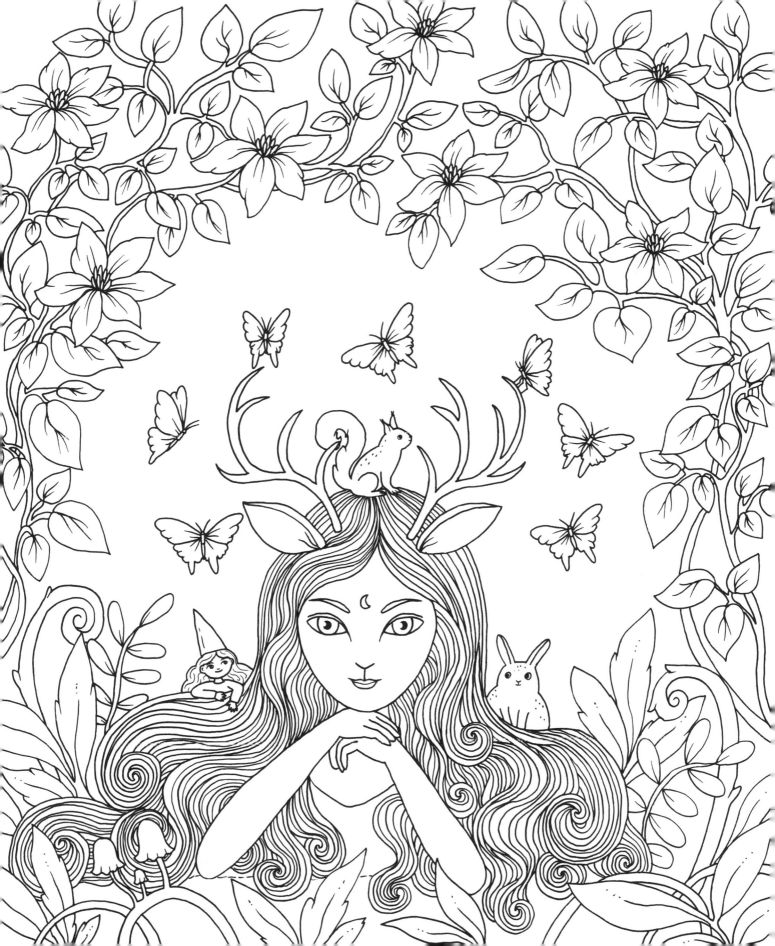

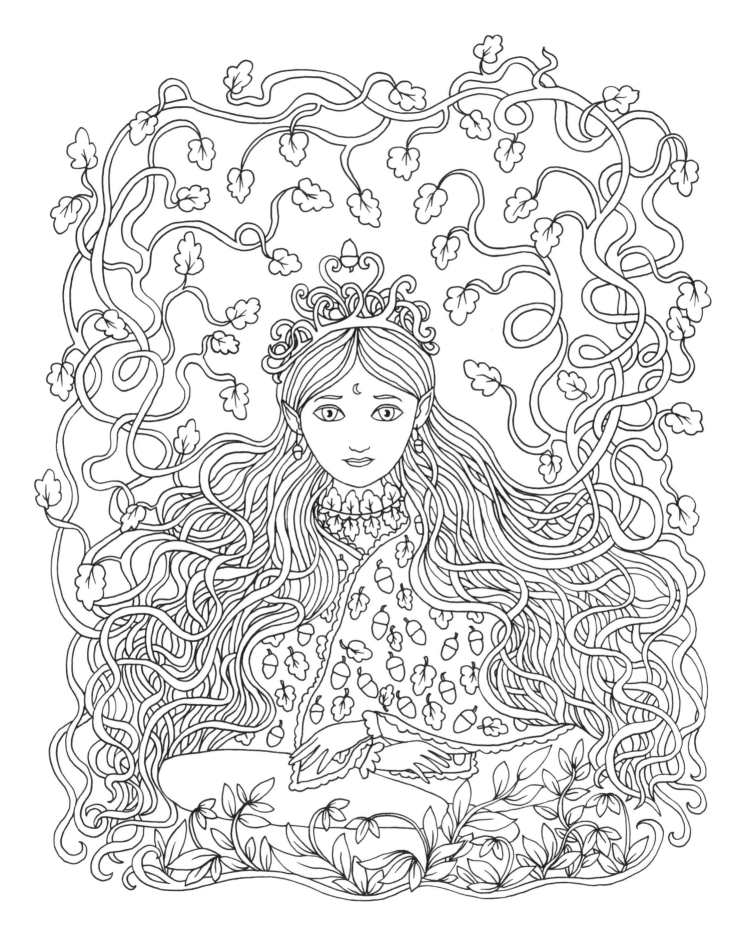

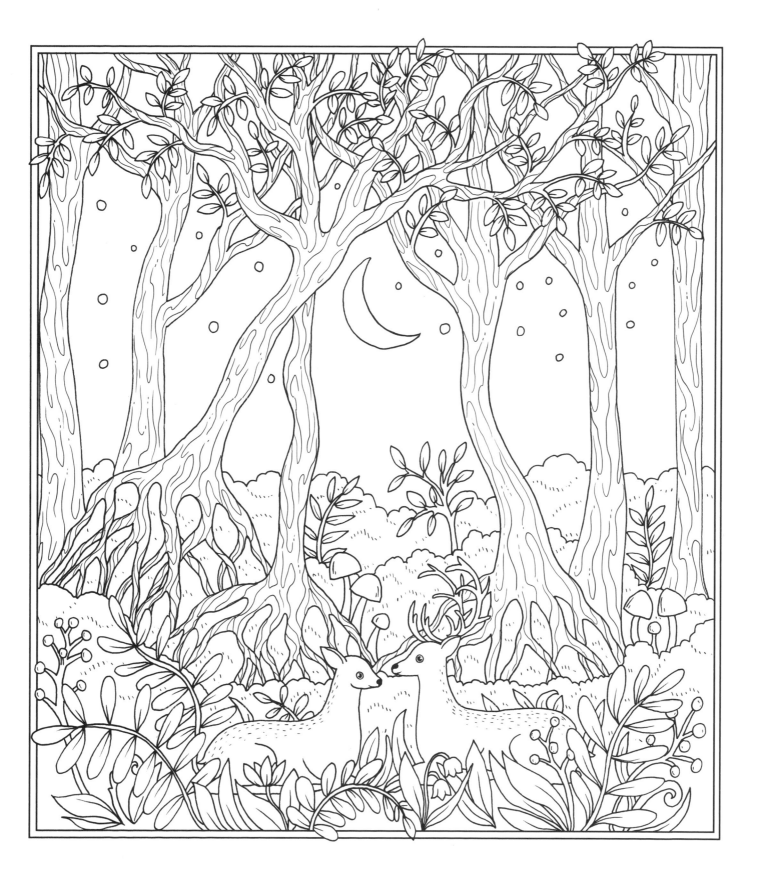

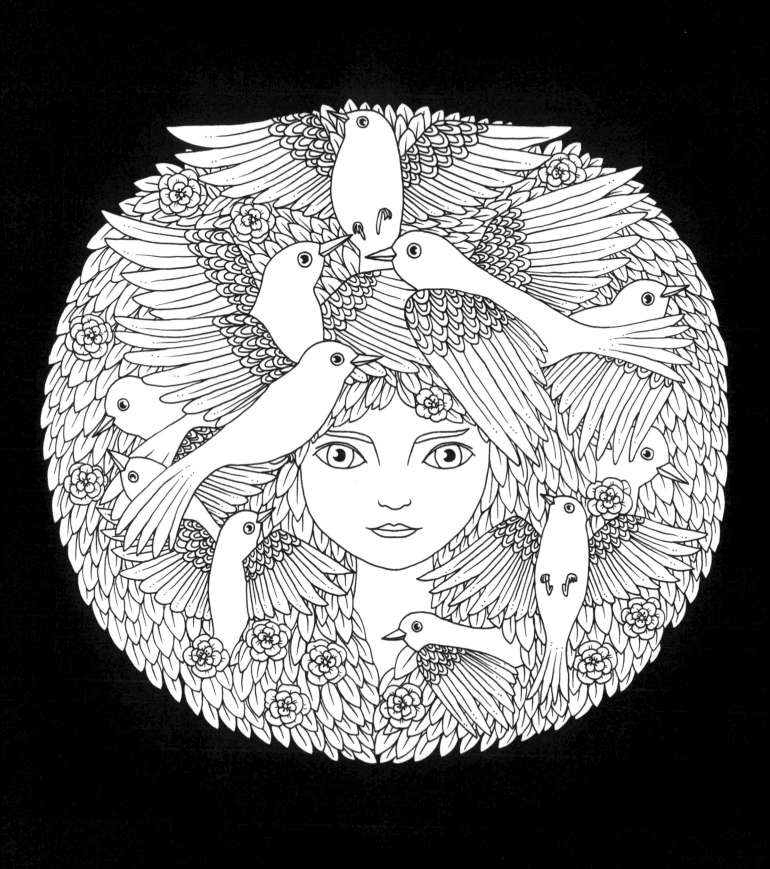

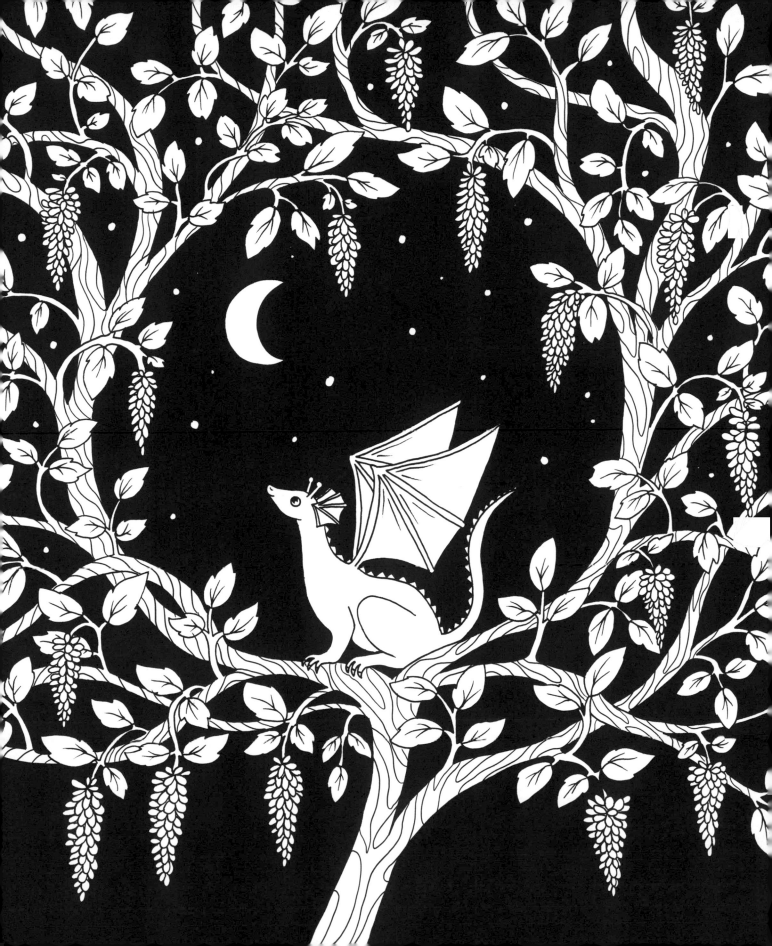

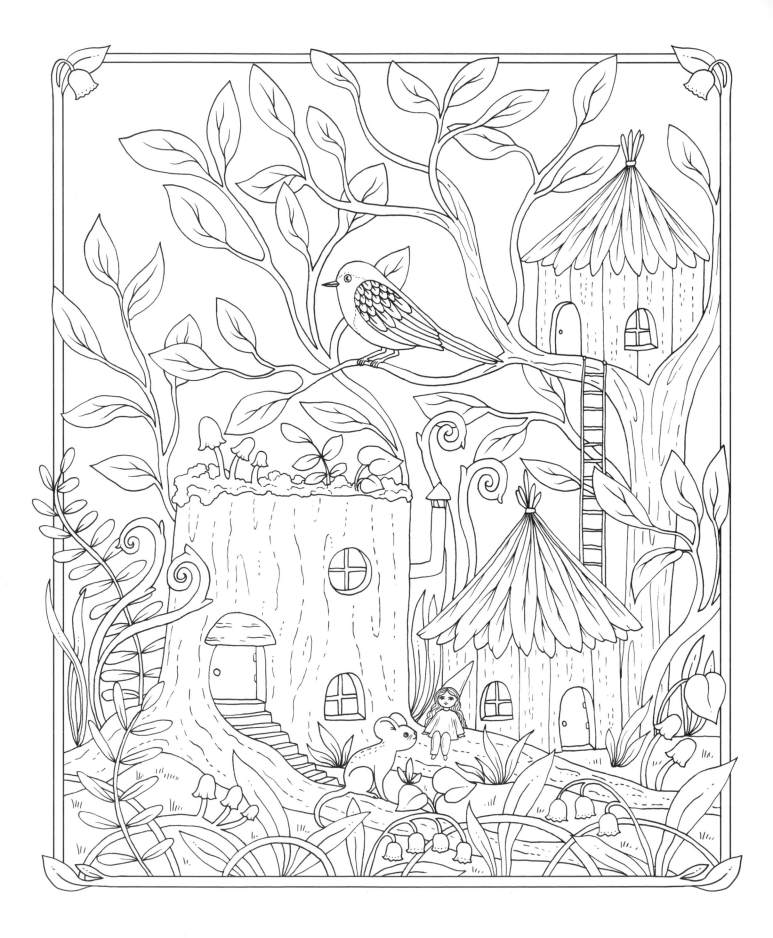

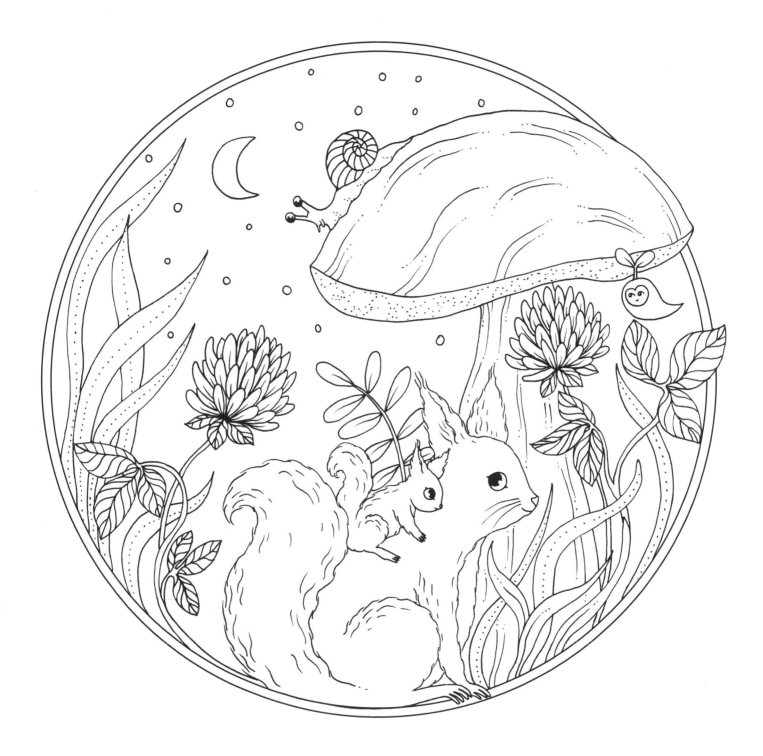

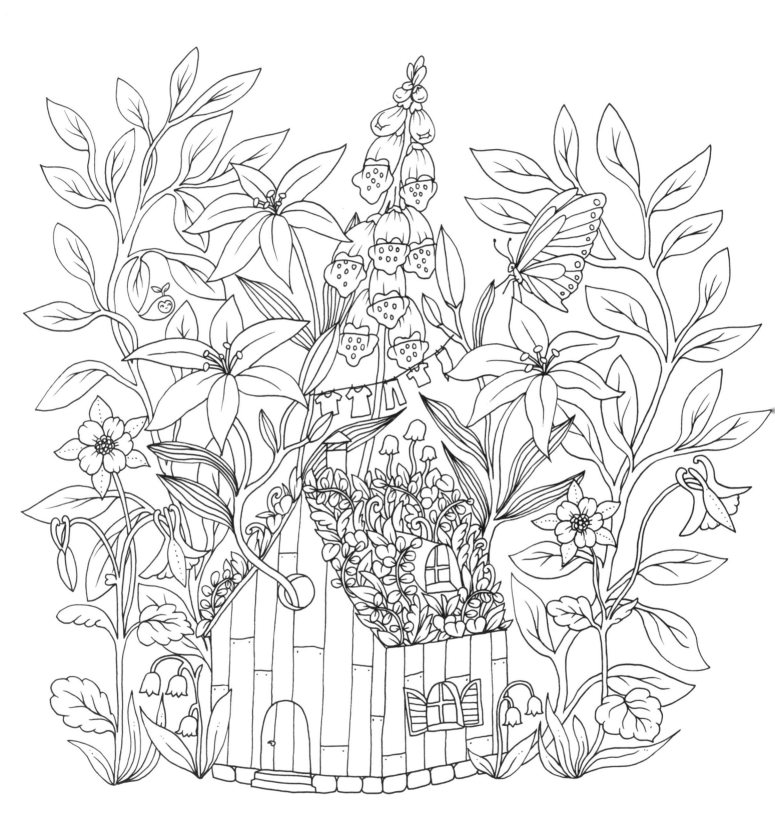

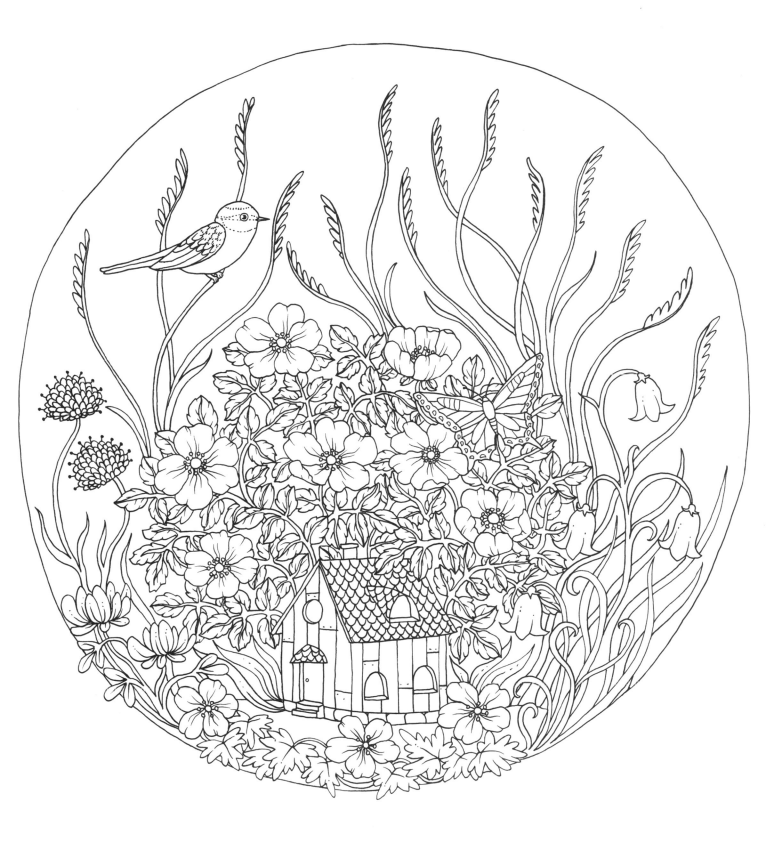

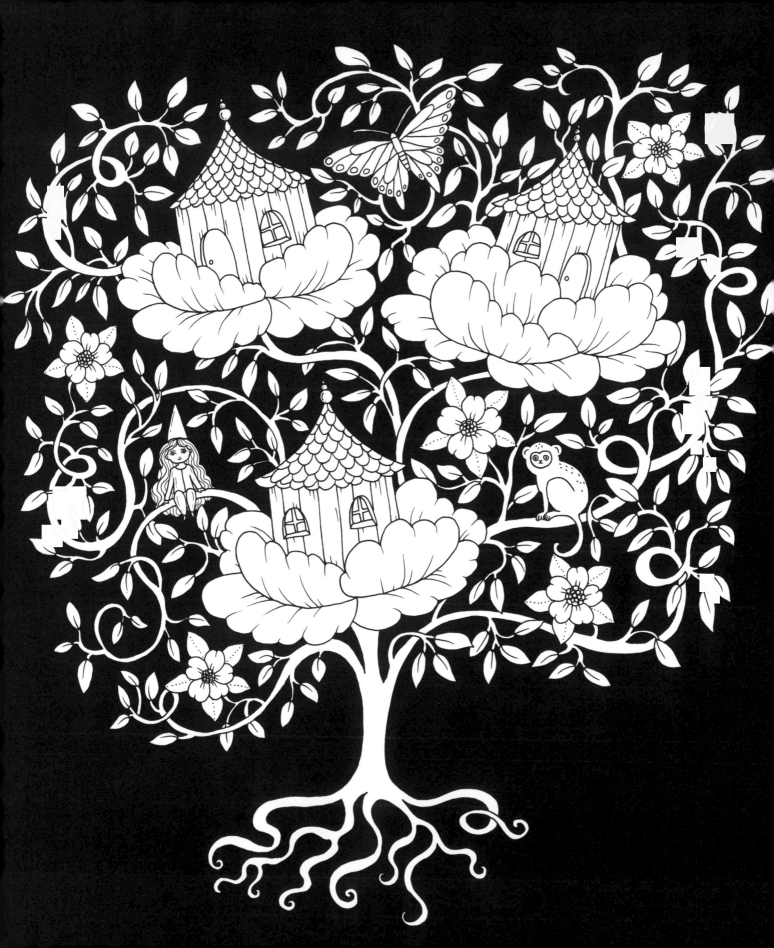

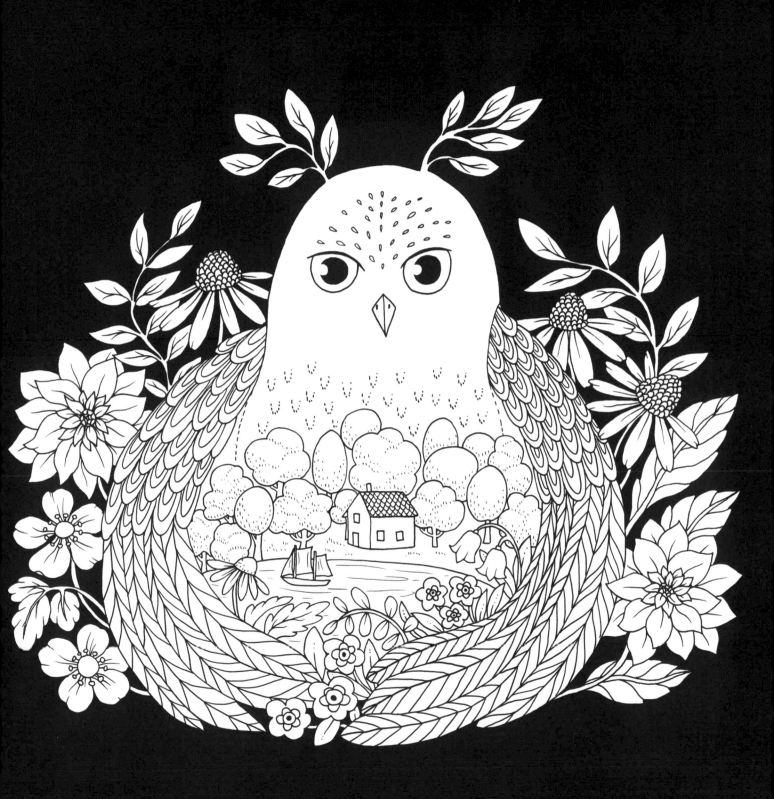

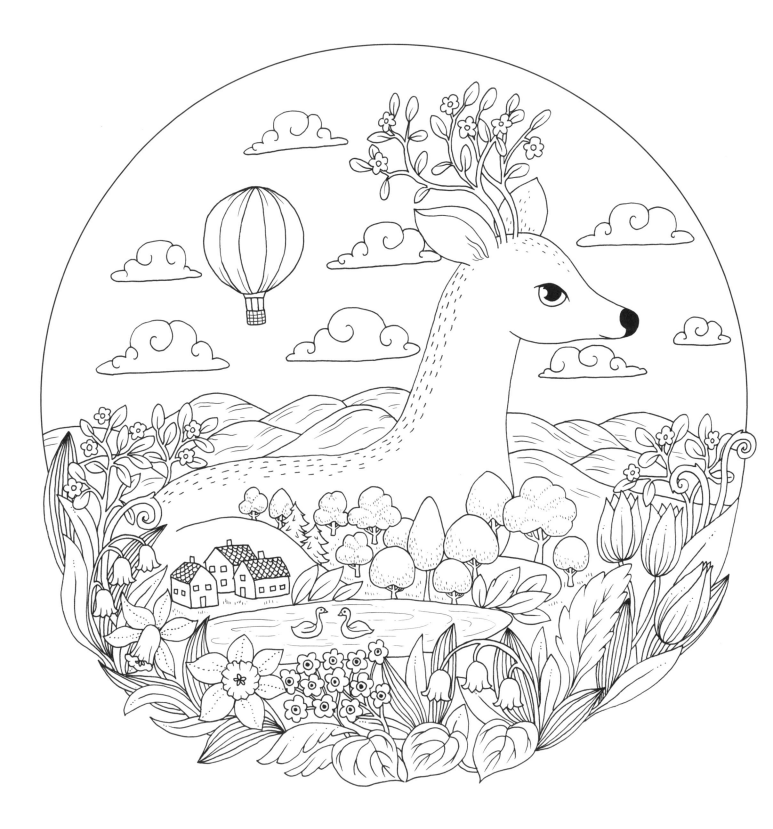

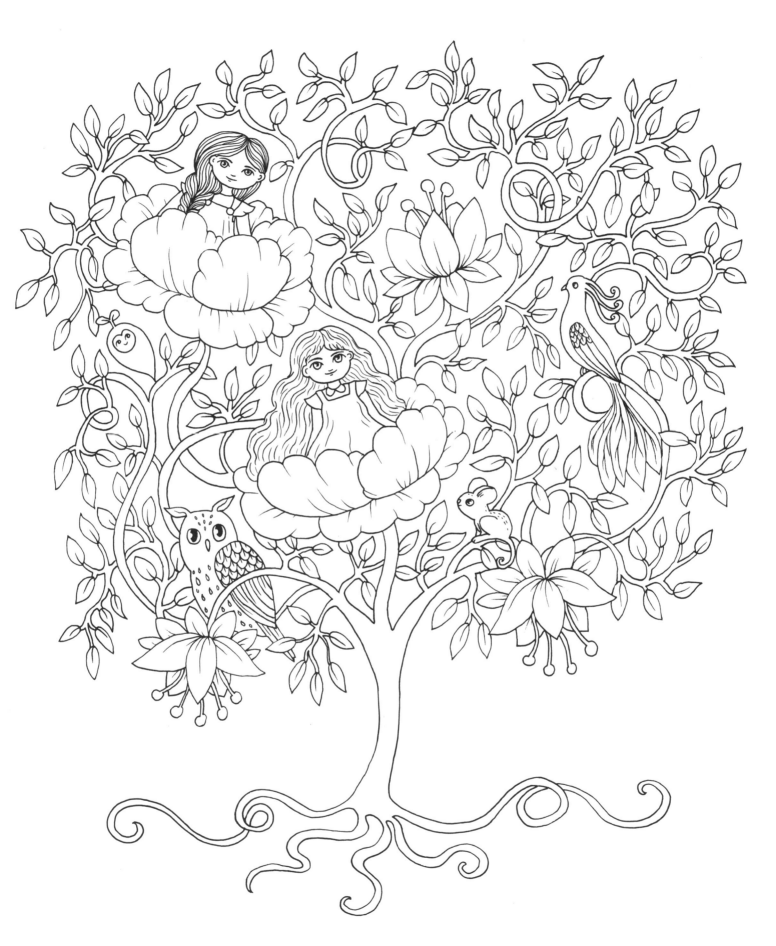

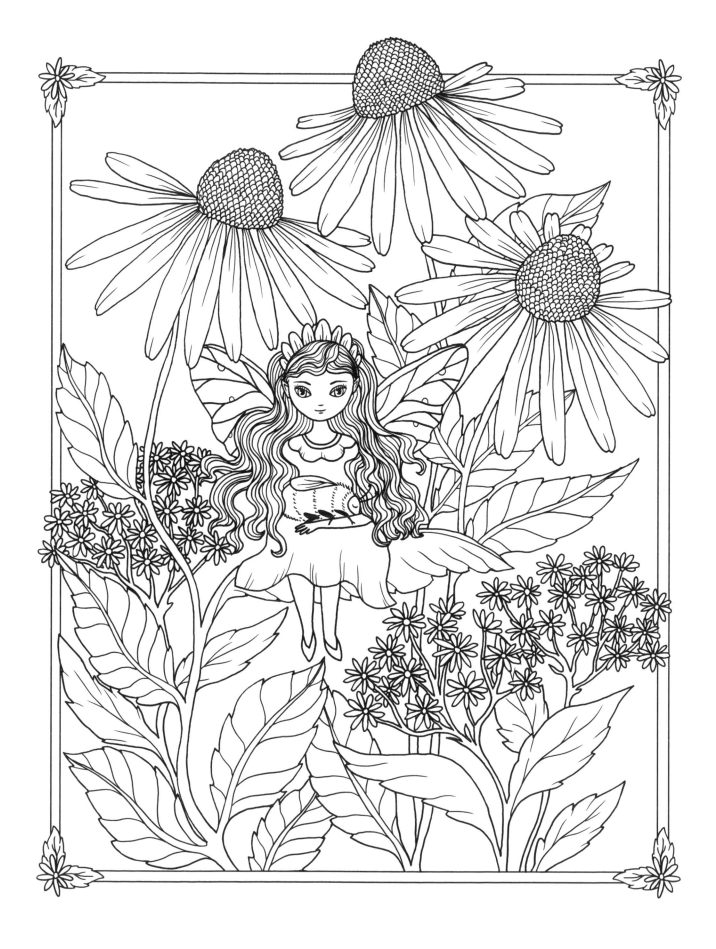

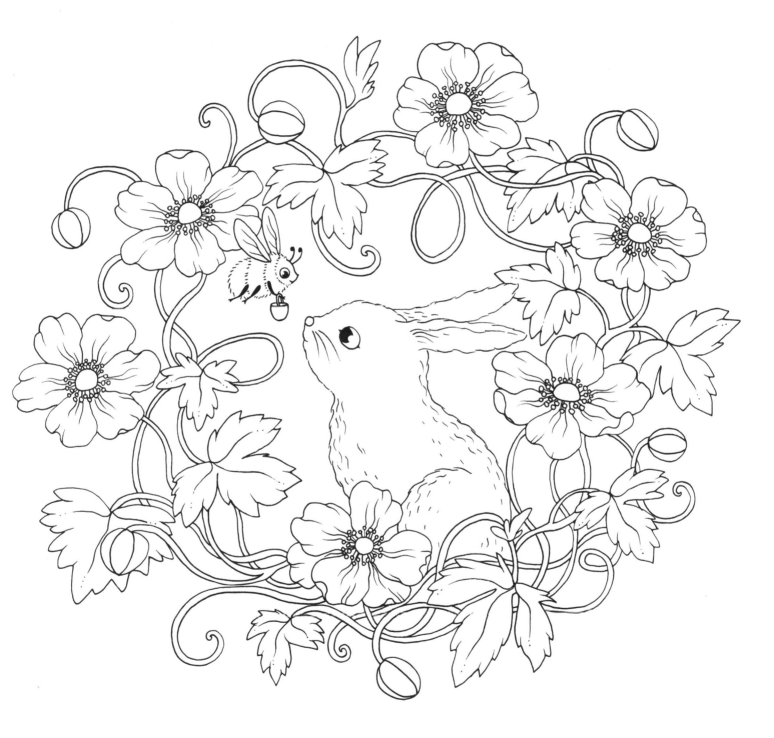

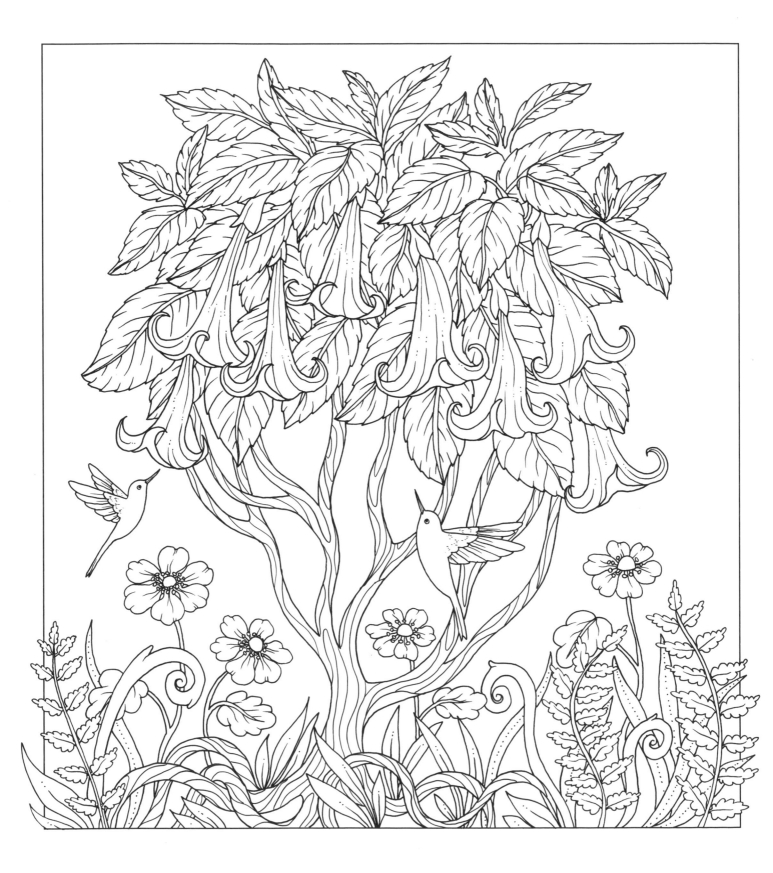

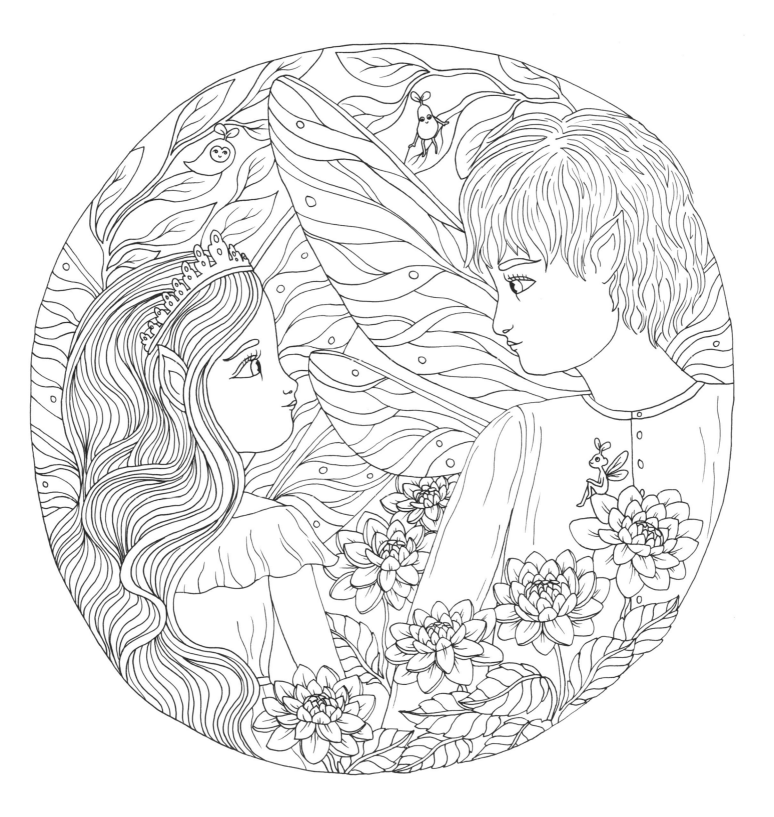

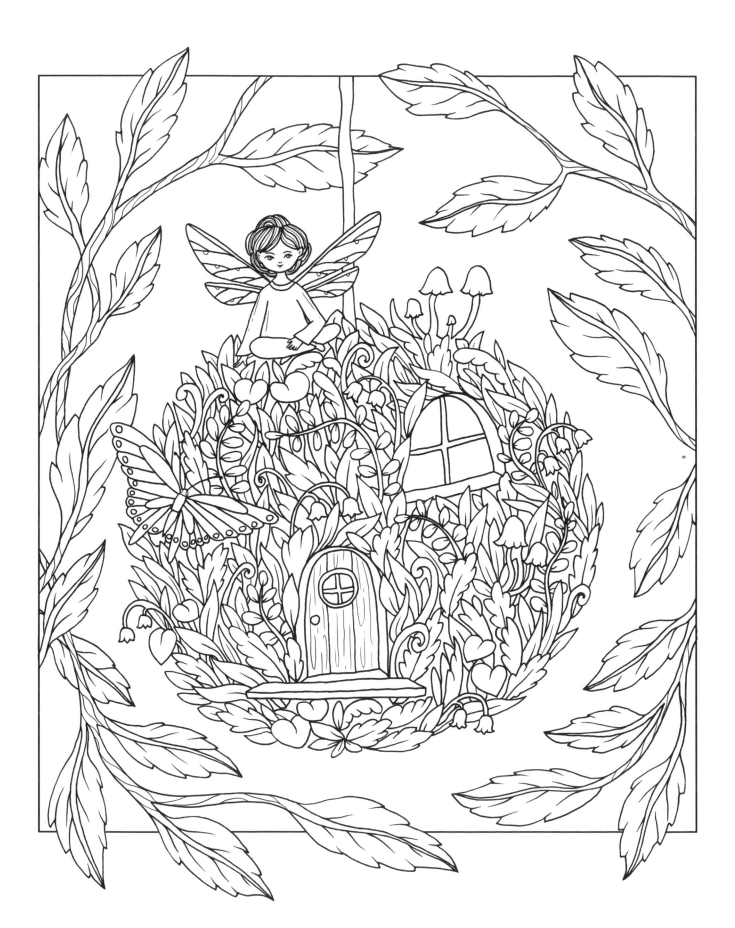

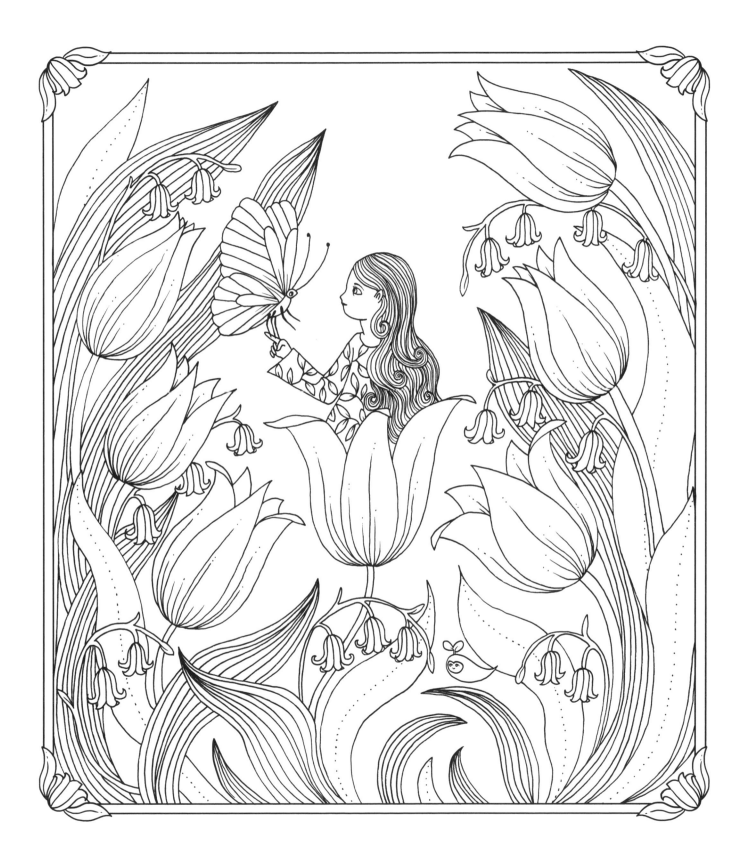

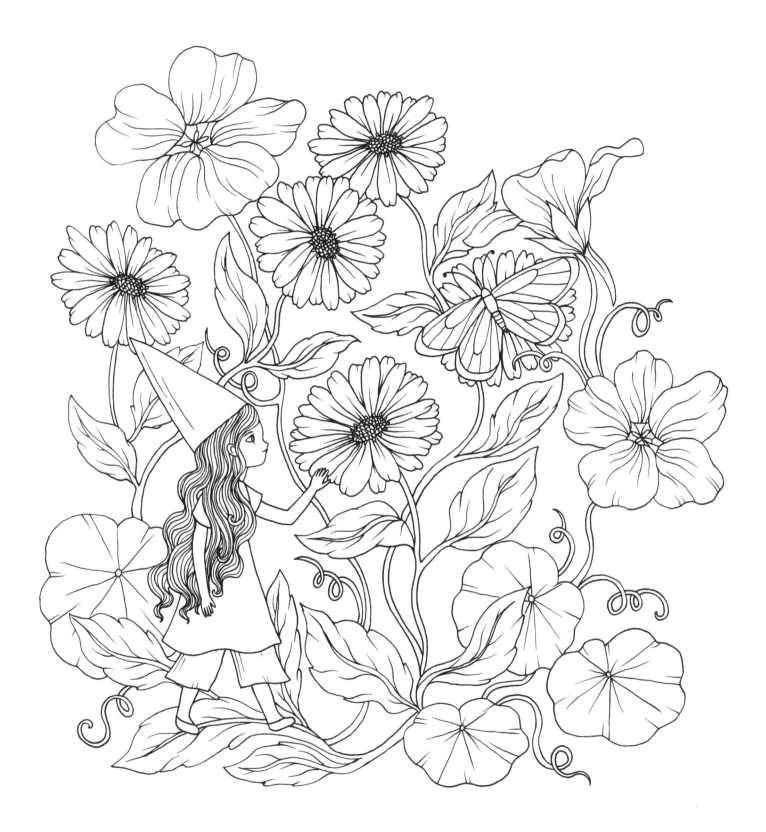

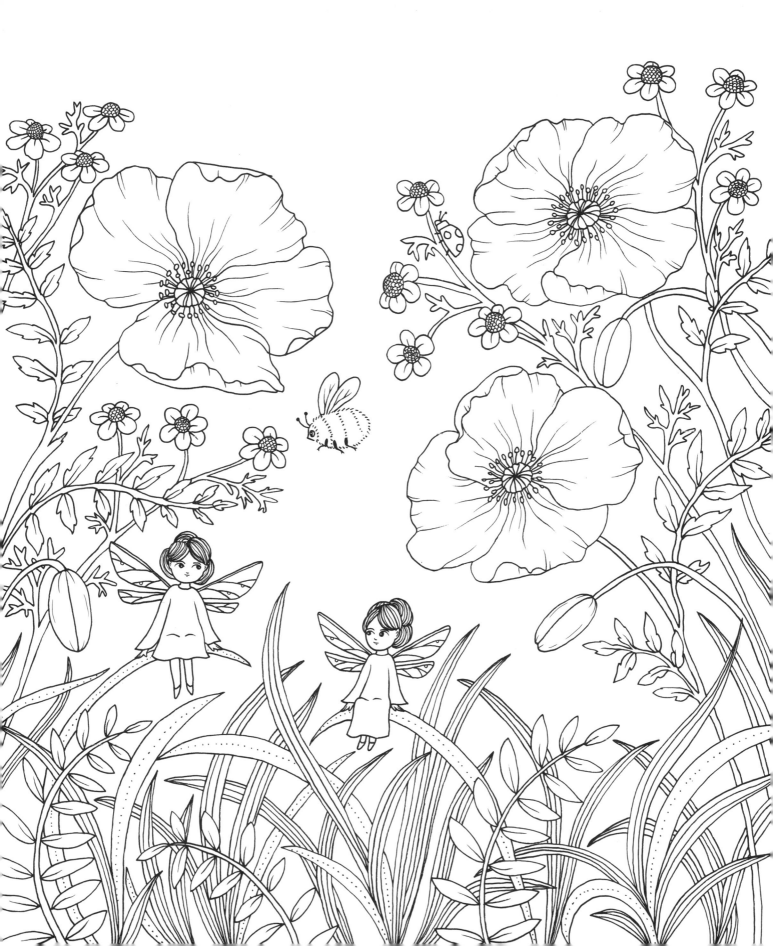

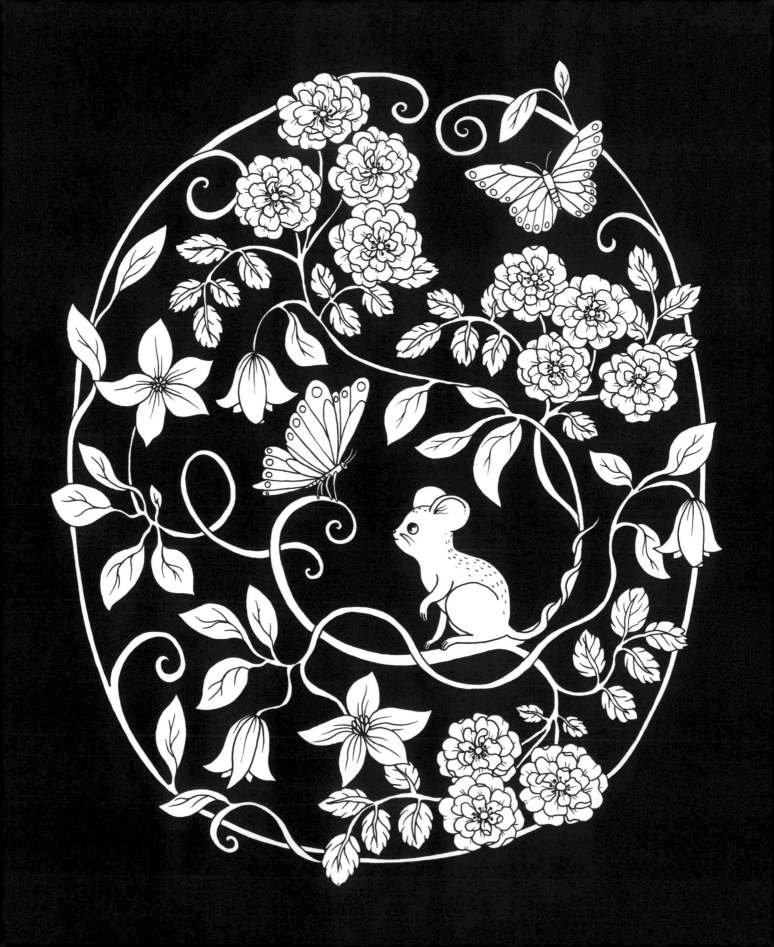

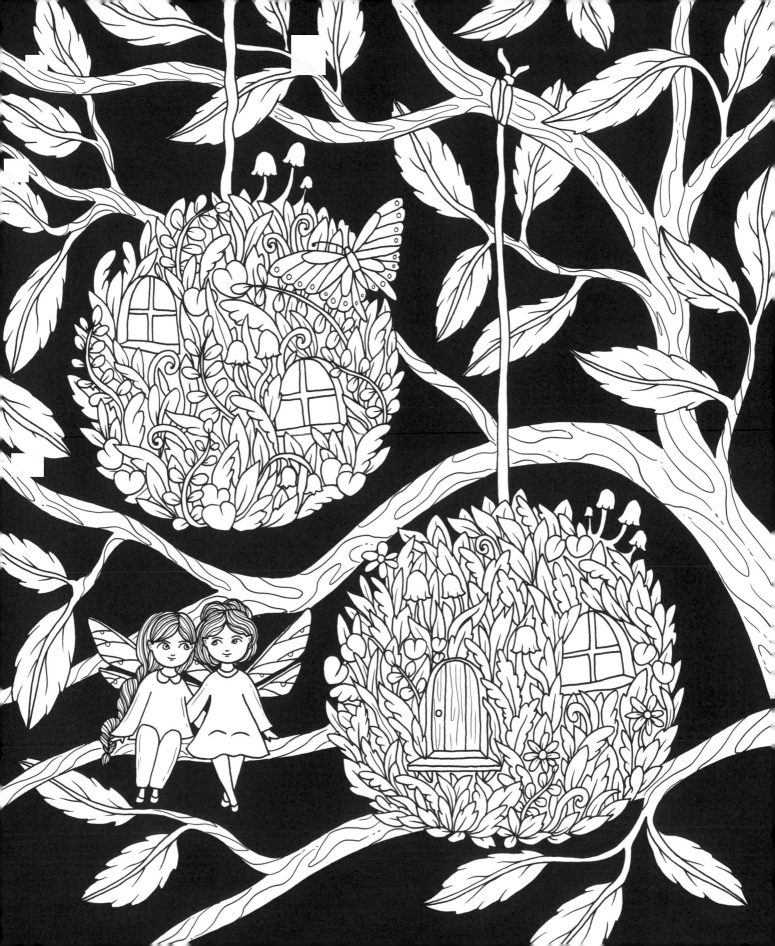

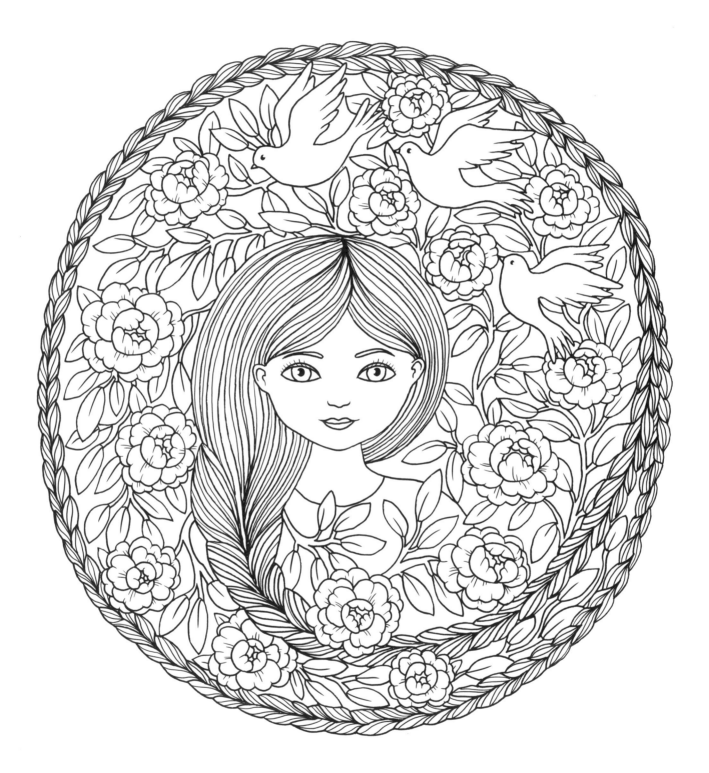

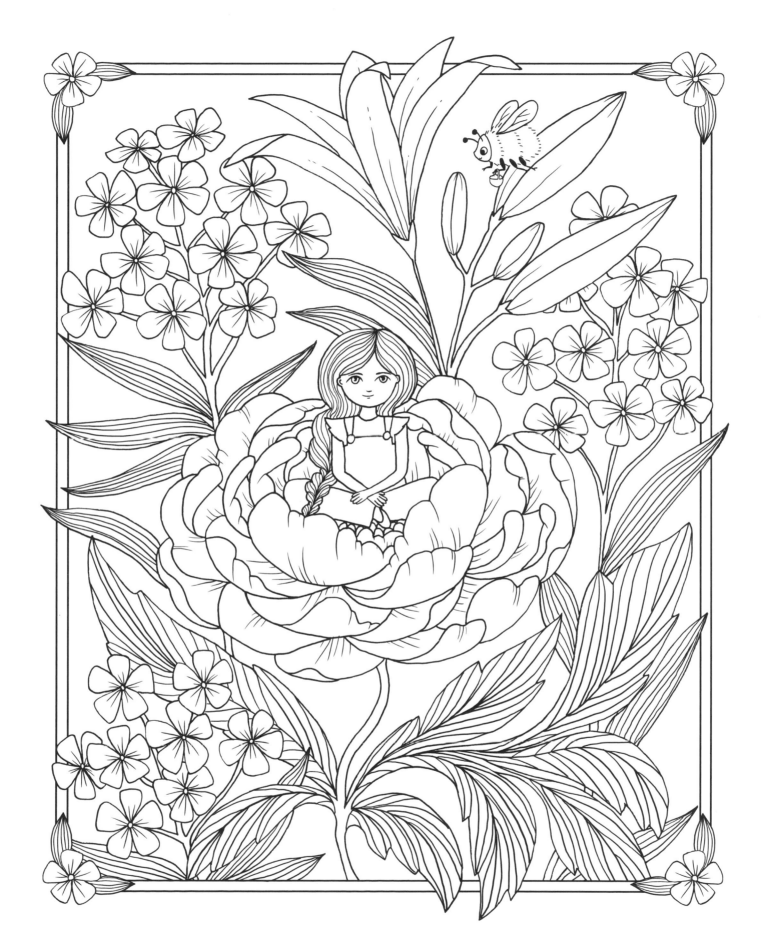

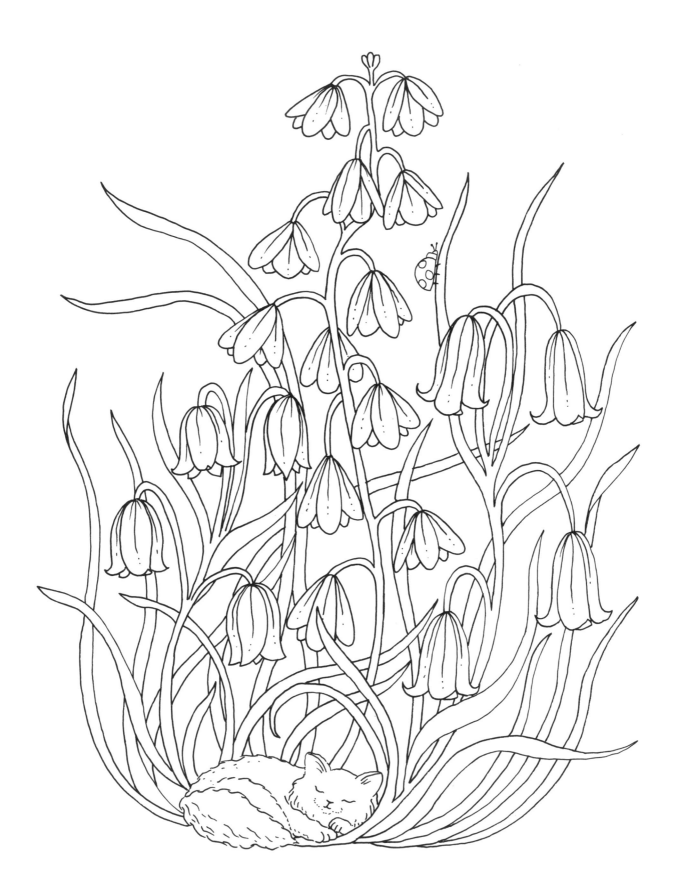

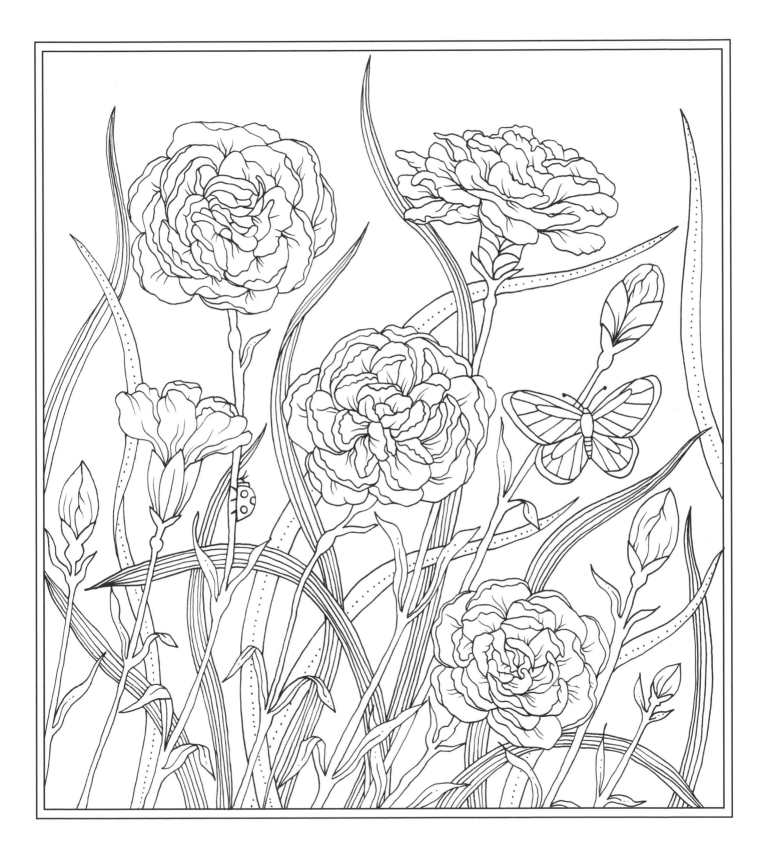

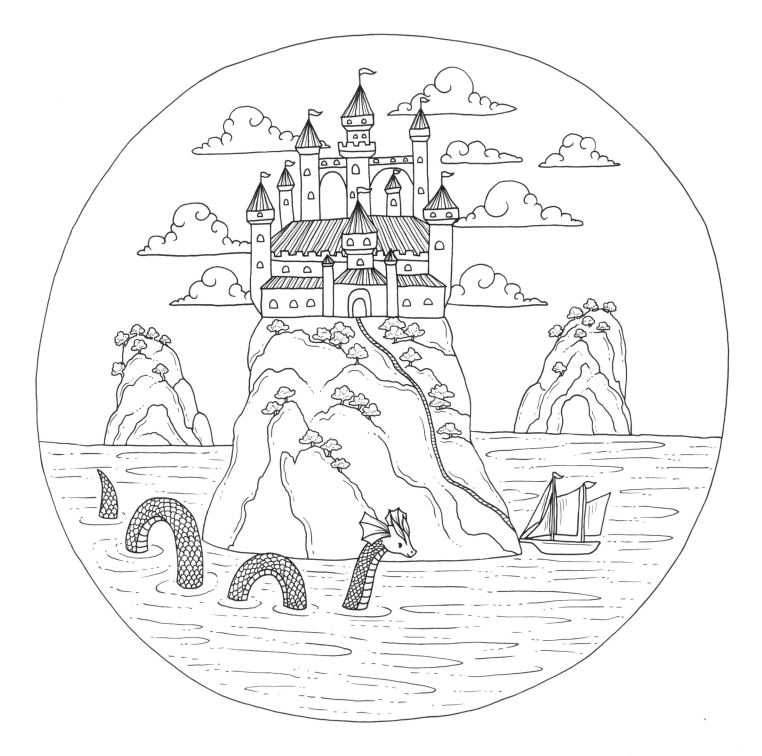

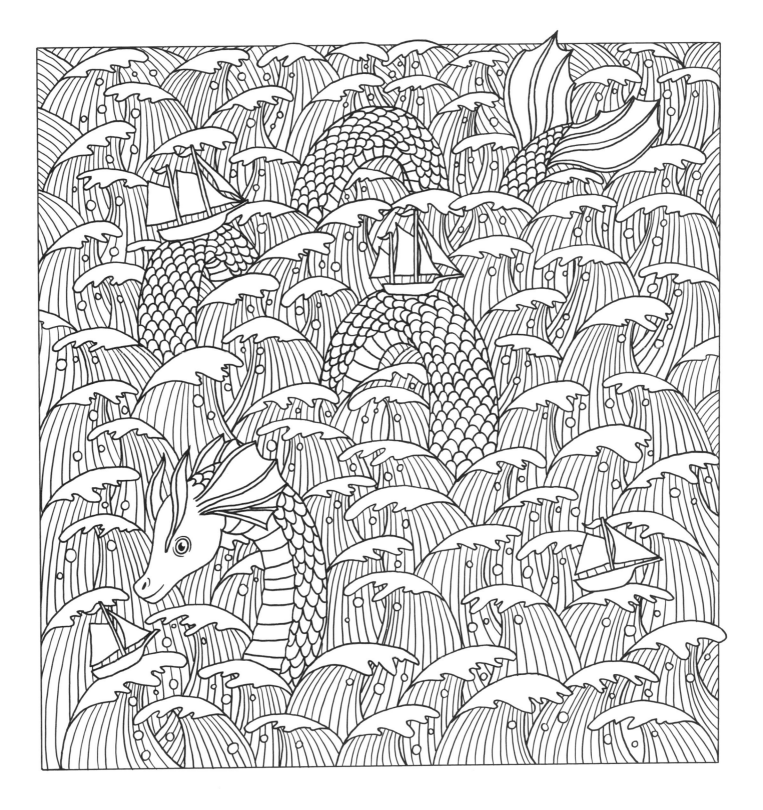

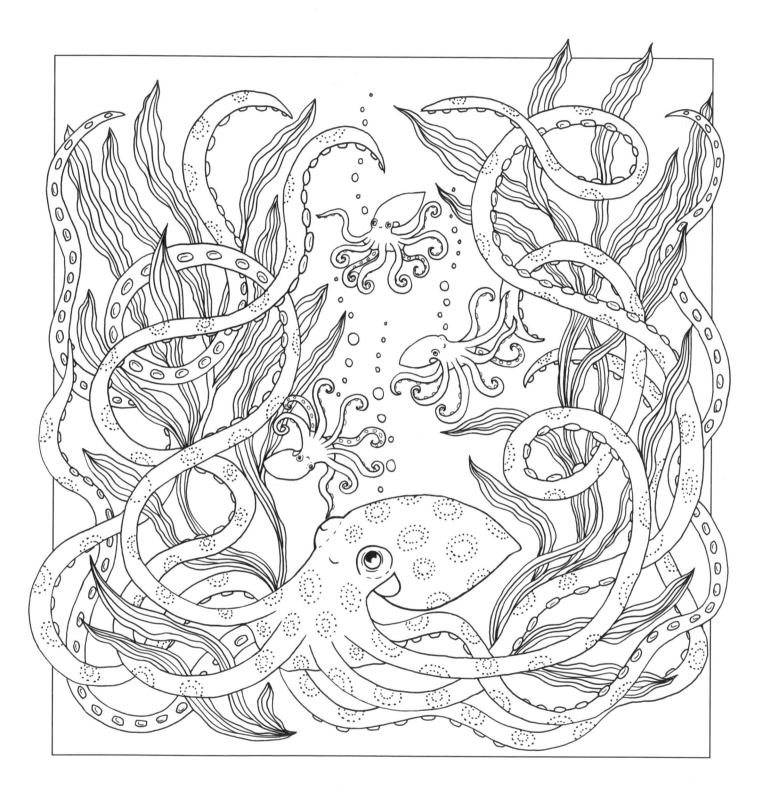

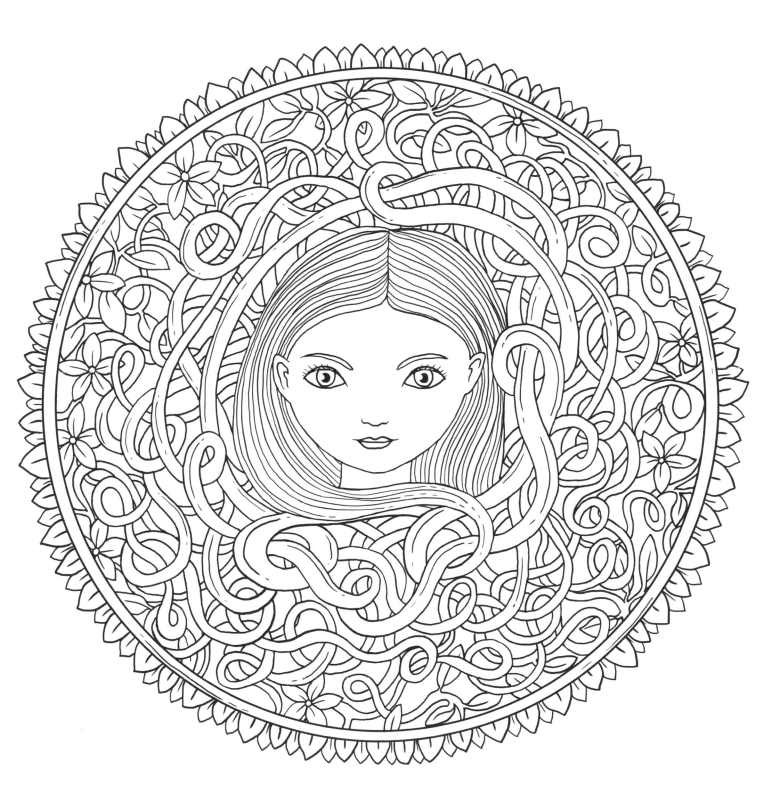

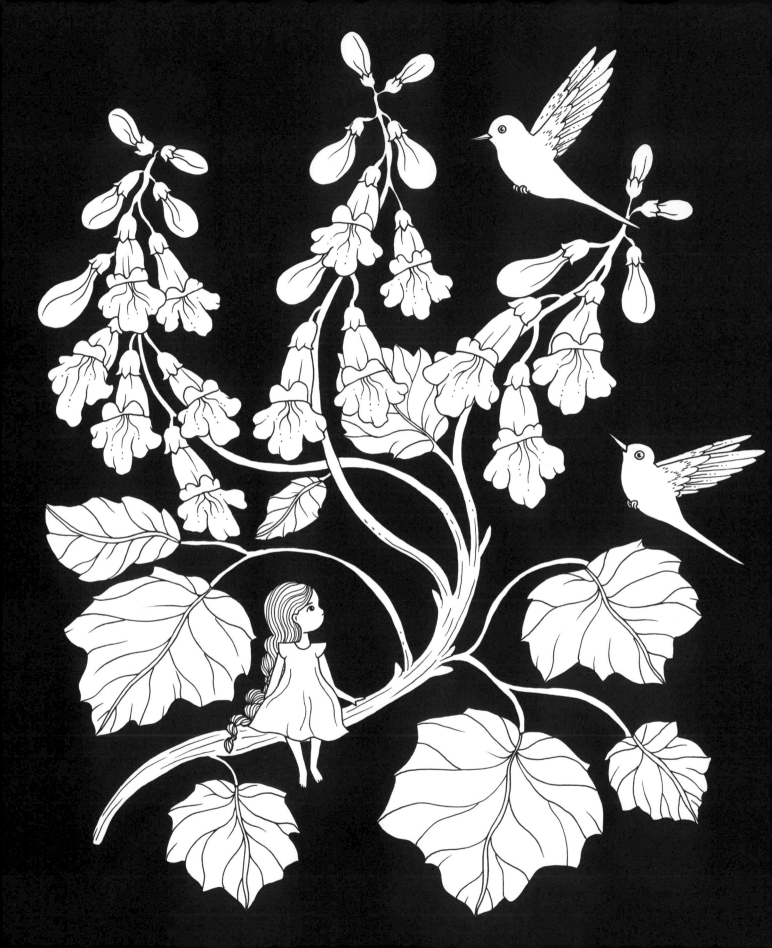

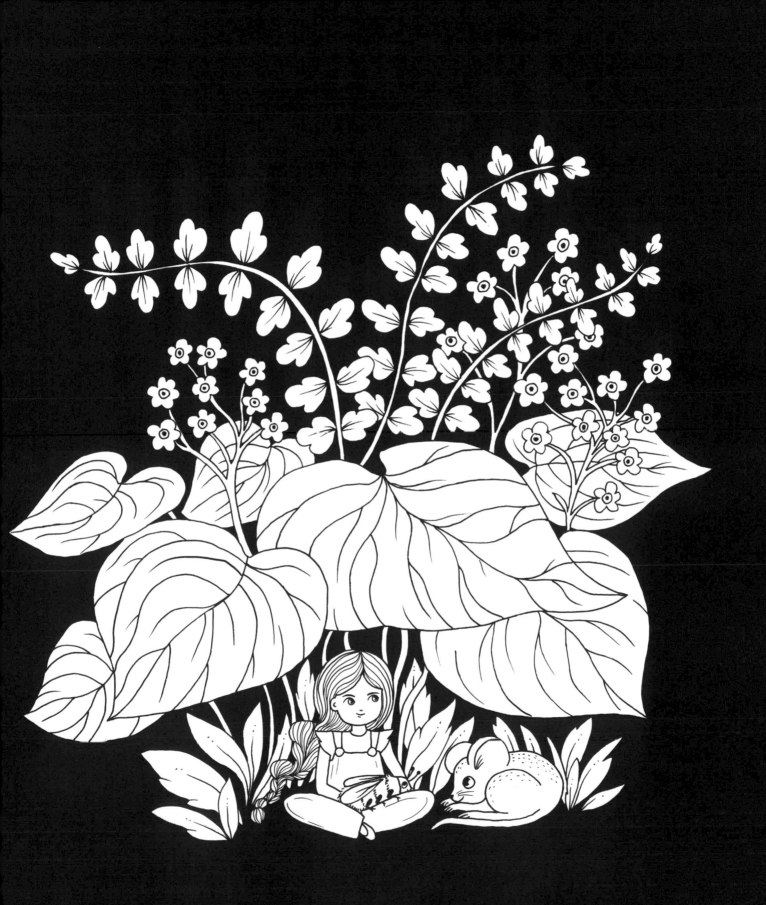

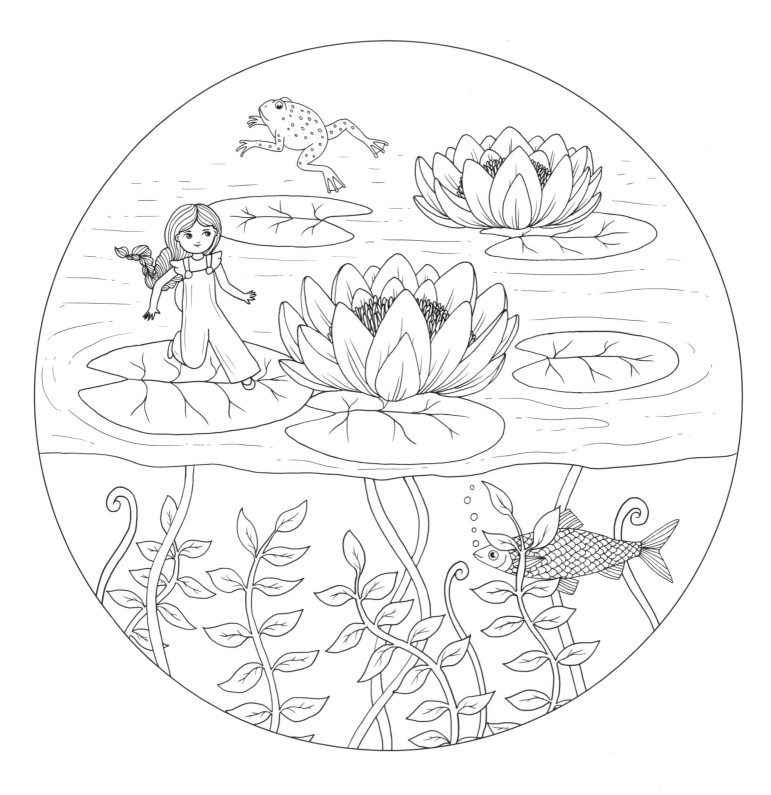

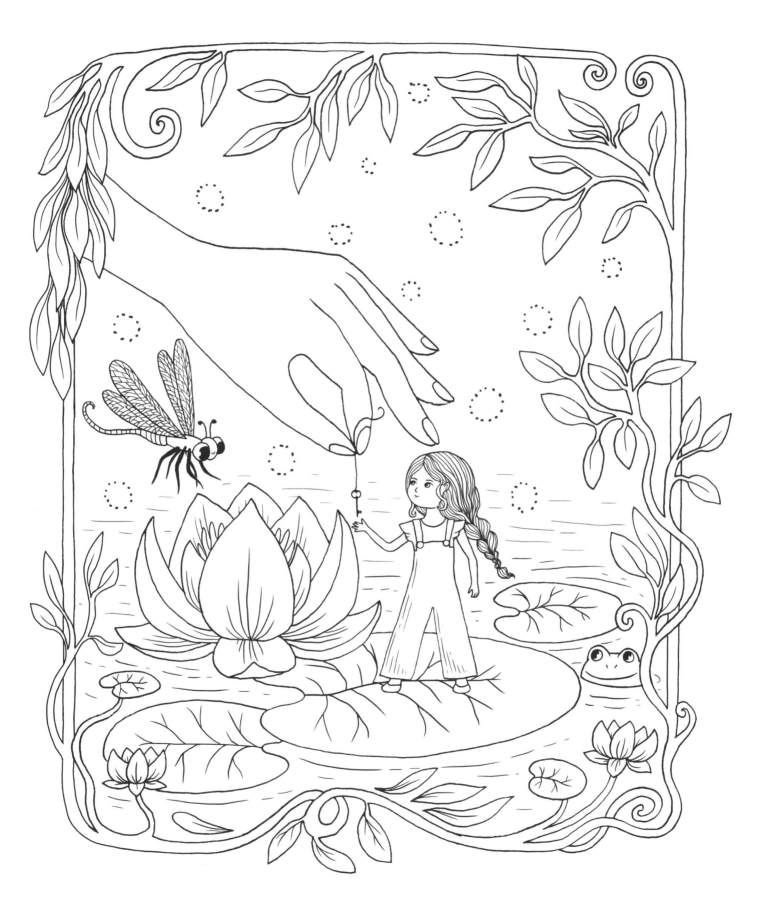

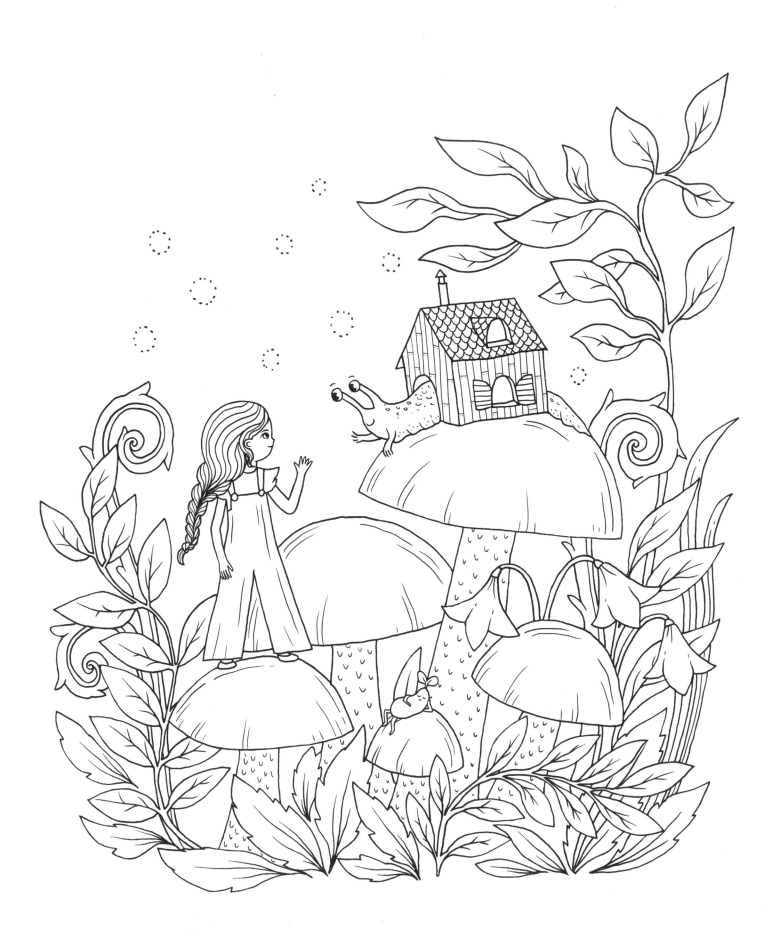

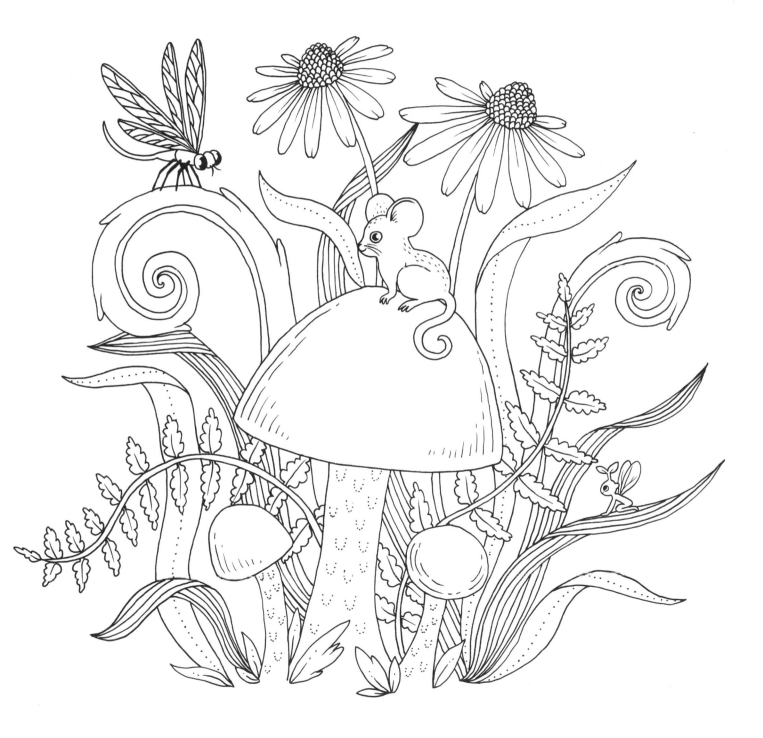

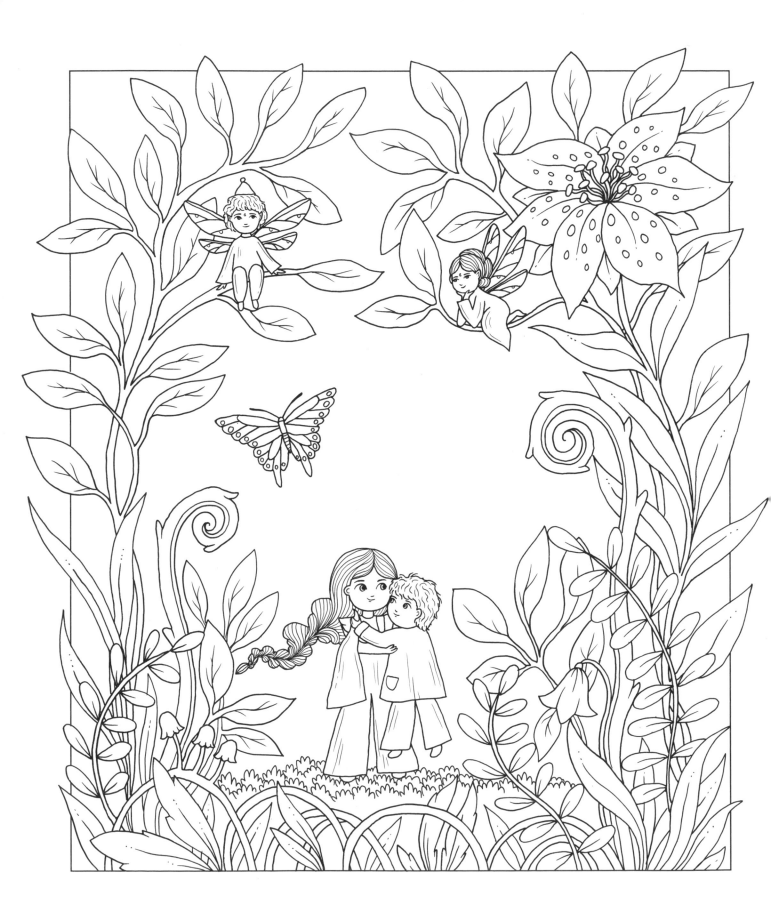

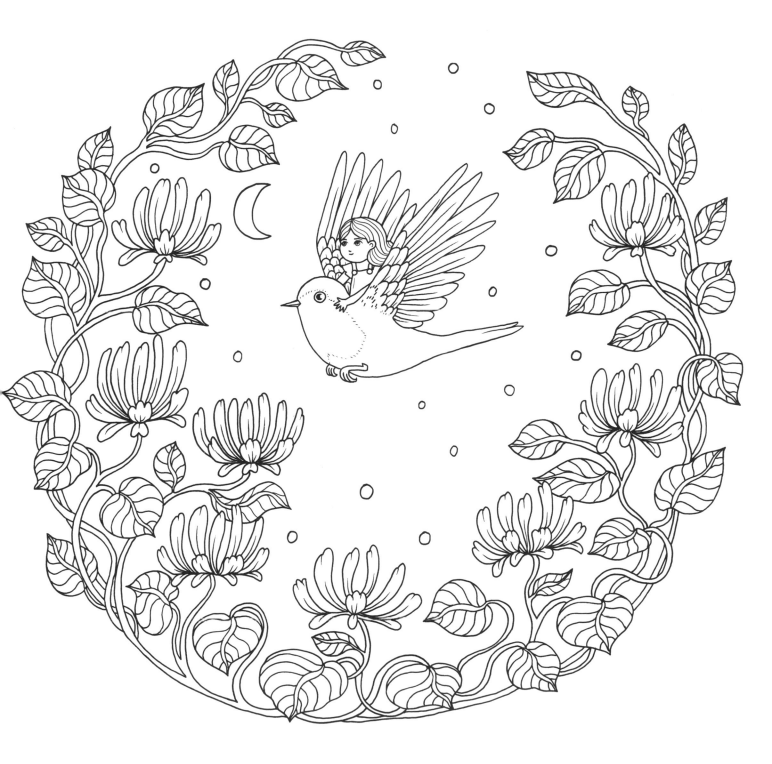

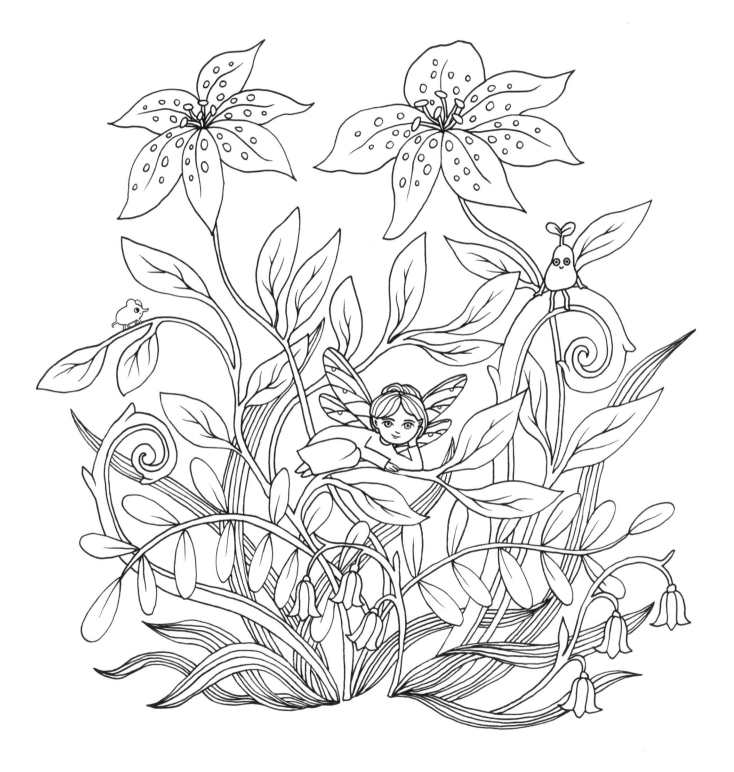

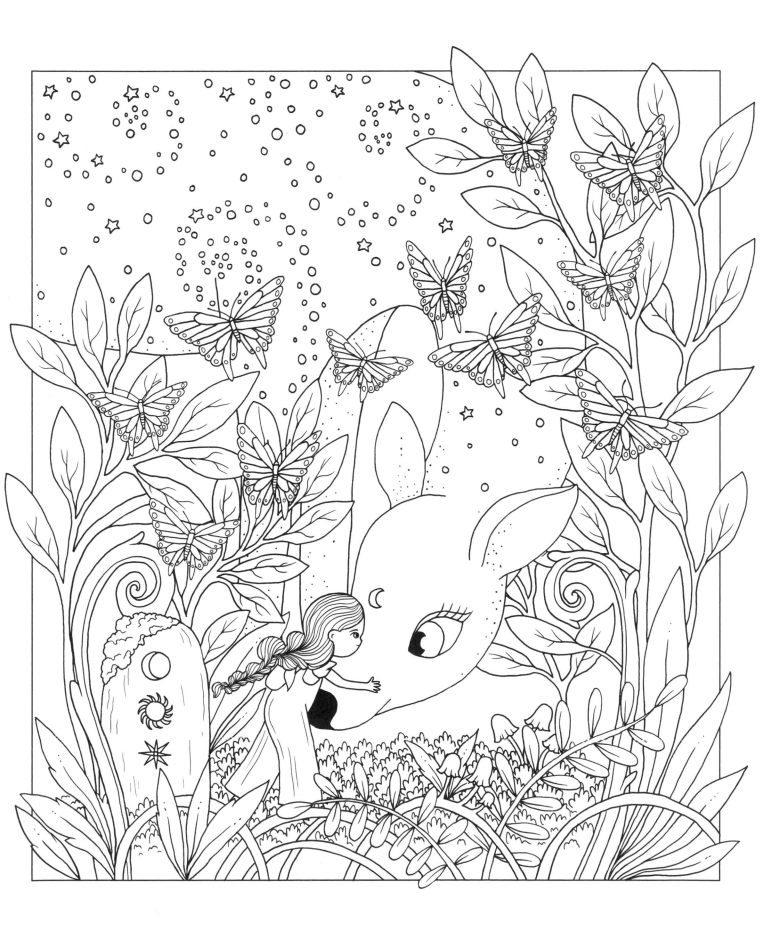

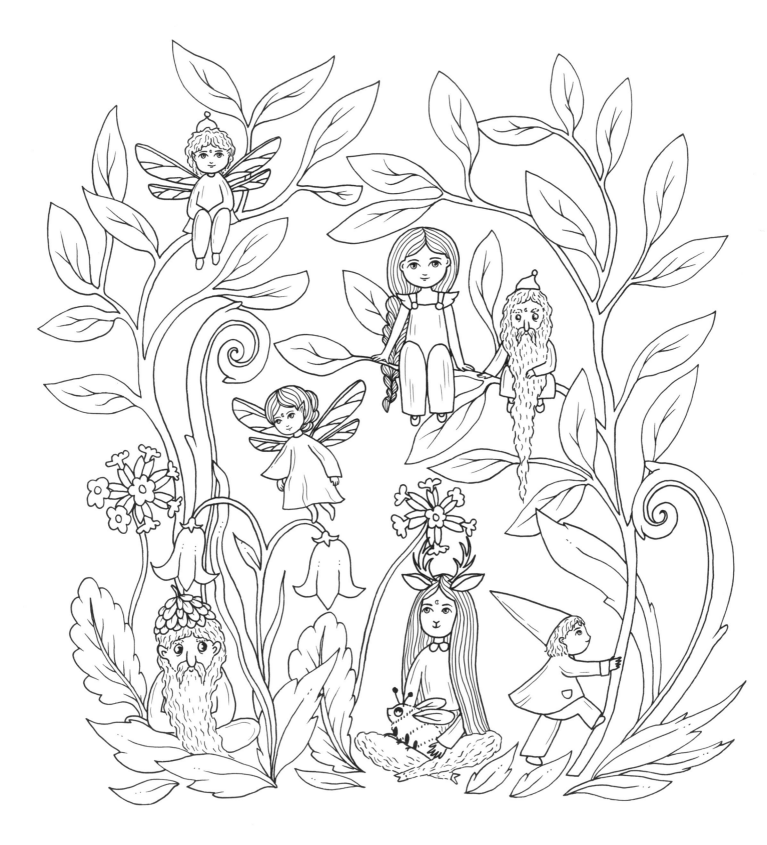

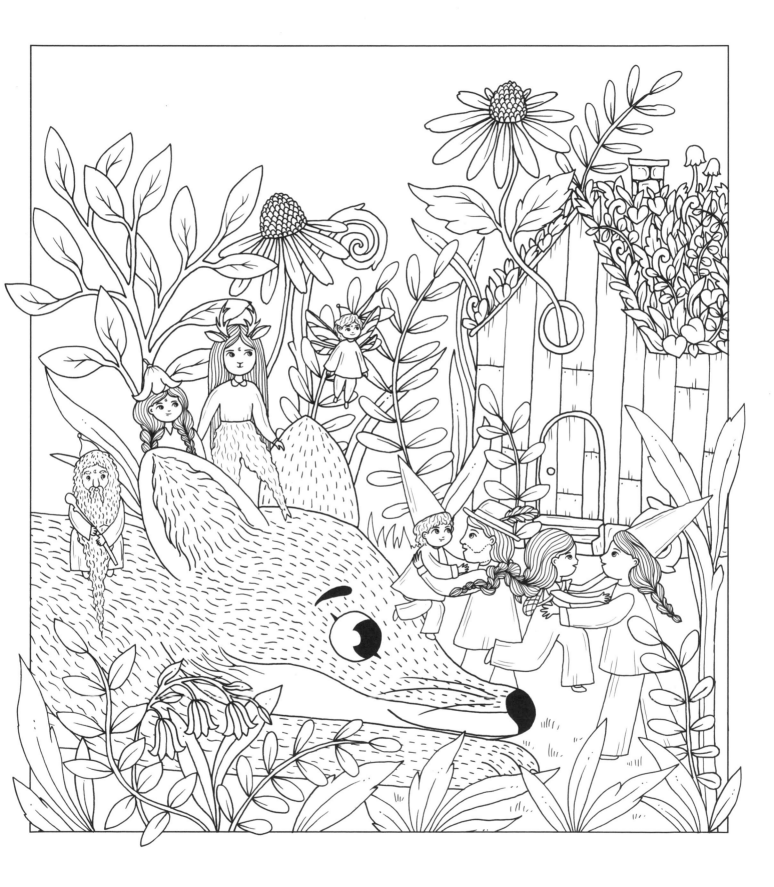

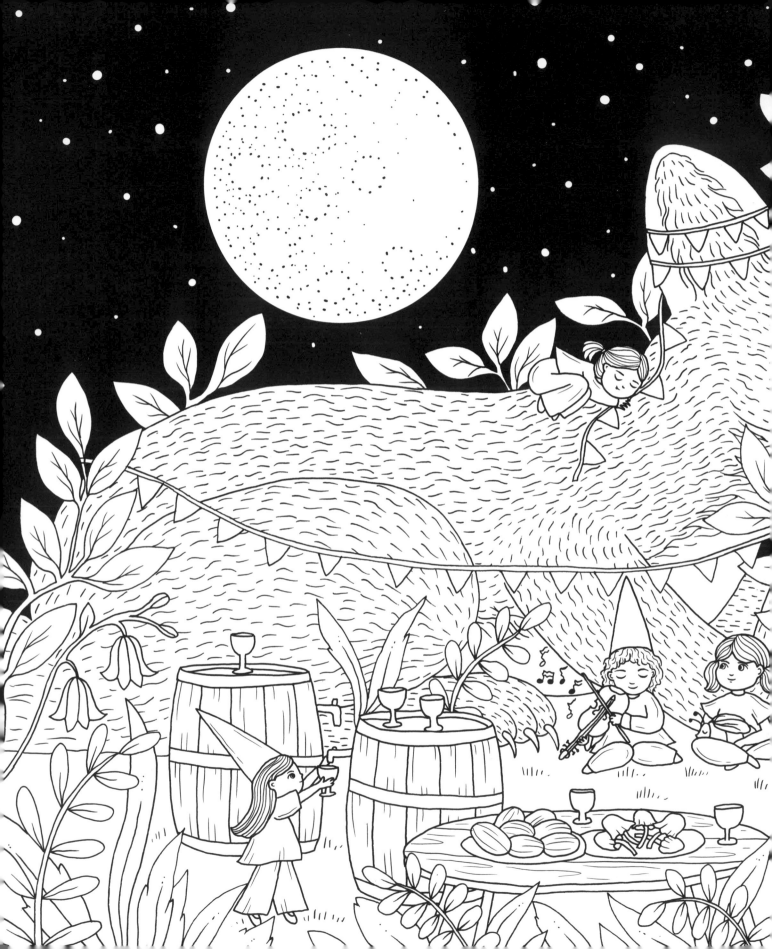

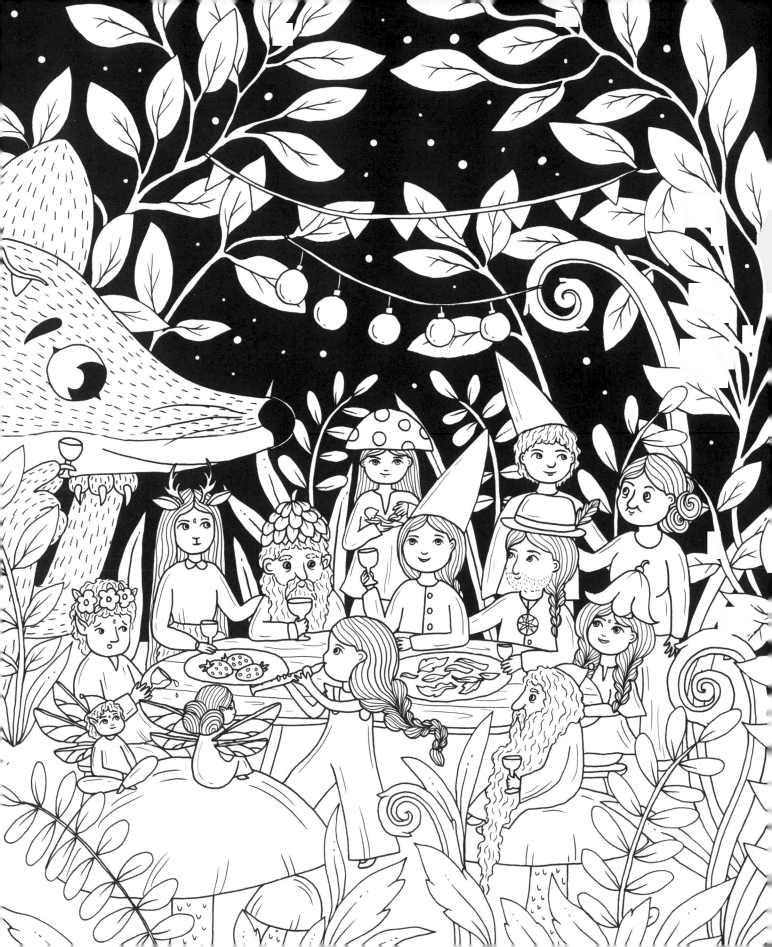

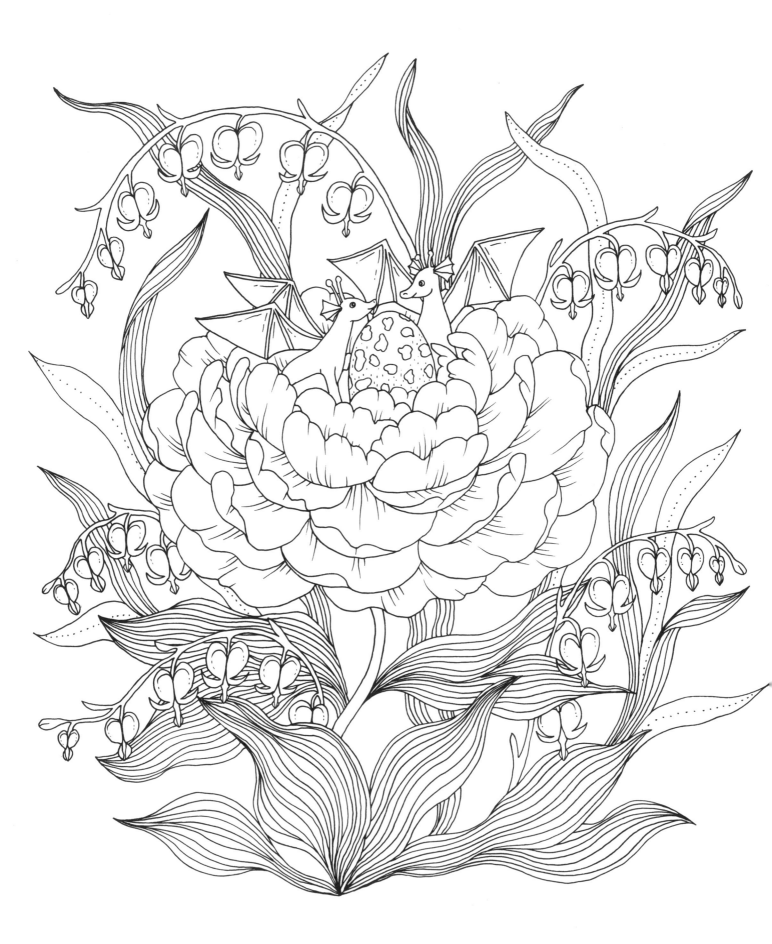

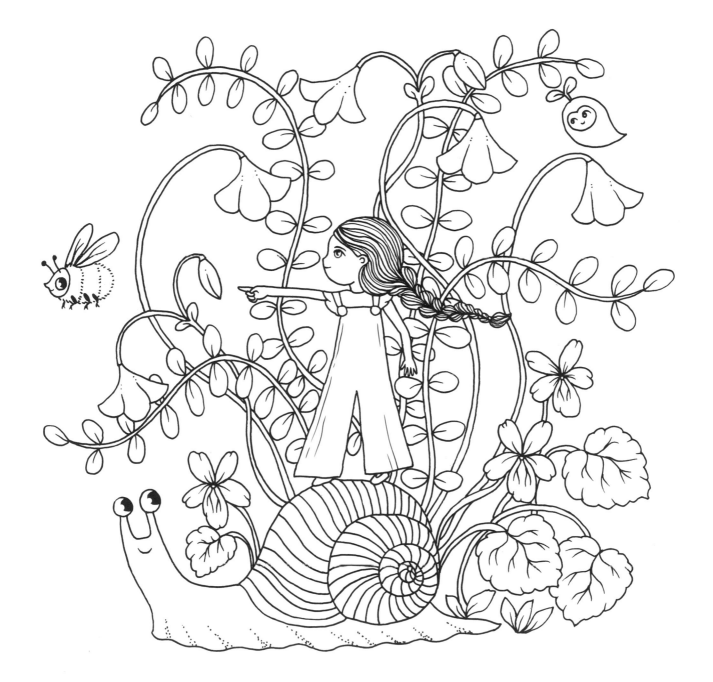

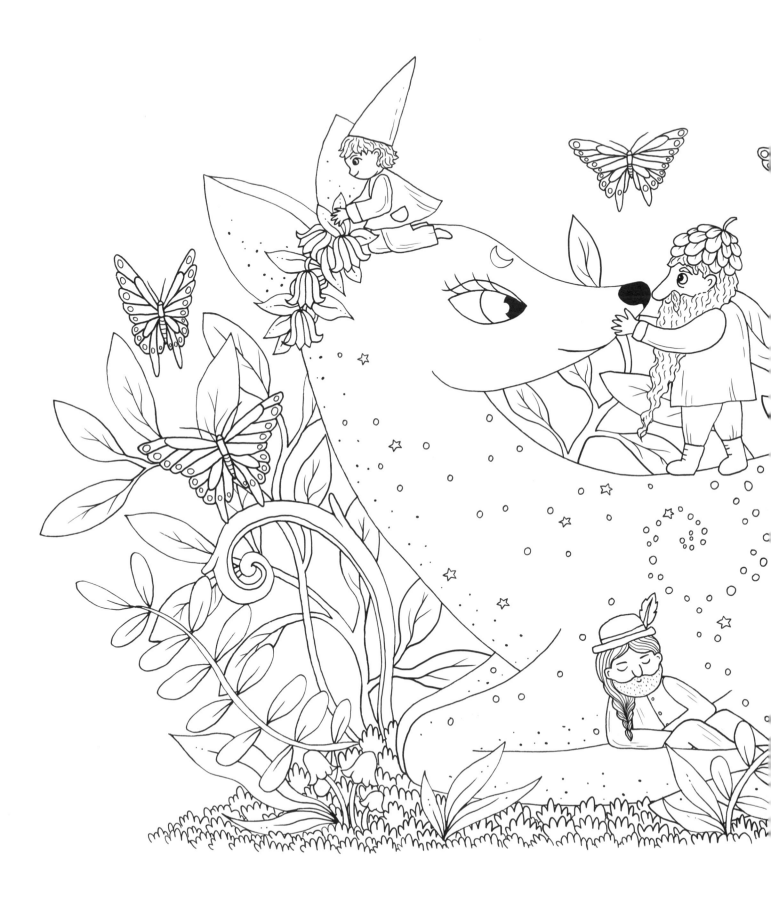

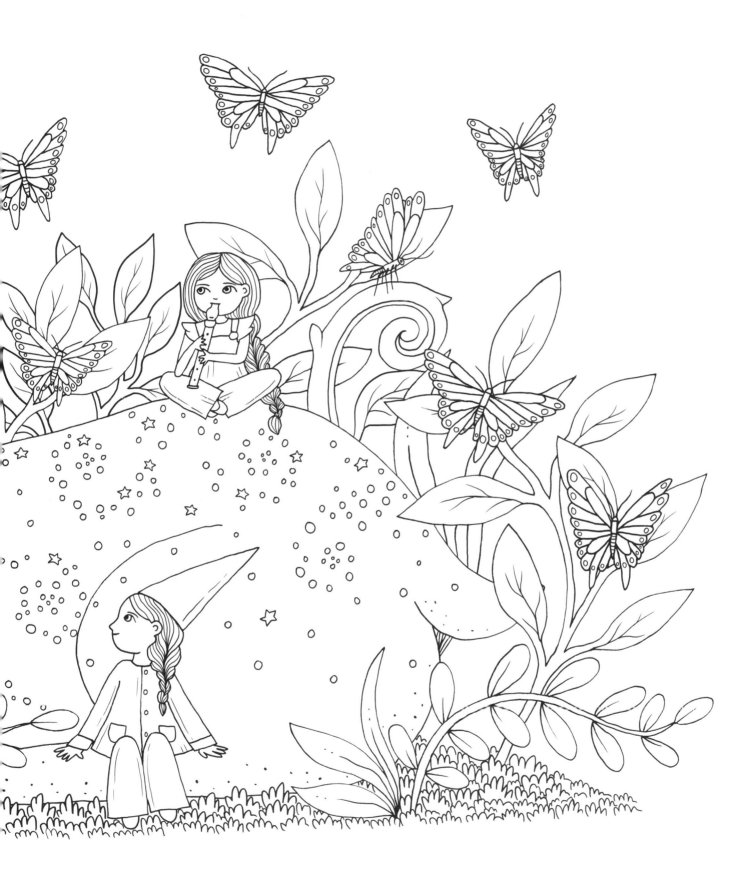

PLANT REGISTER

Plant names listed page by page; numbering begins
with the title page as 1.

ANIMAL REGISTER

Animal names listed page by page; numbering begins
with the title page as 1.

TEST YOUR PENS HERE.